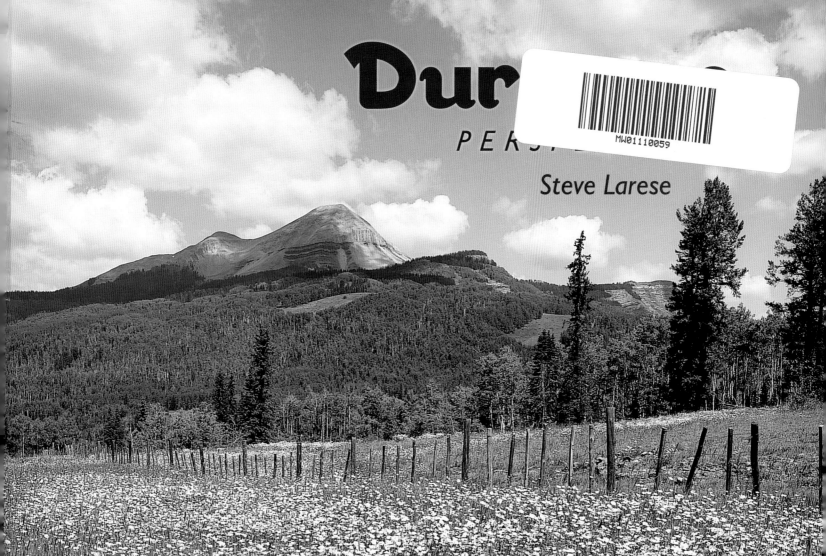

Dur
PERSP

Steve Larese

4880 Lower Valley Road, Atglen, PA 19310

Schiffer Books are available at special discounts for bulk purchases for sales promotions or premiums. Special editions, including personalized covers, corporate imprints, and excerpts can be created in large quantities for special needs. For more information contact the publisher:

Published by Schiffer Publishing Ltd.
4880 Lower Valley Road
Atglen, PA 19310
Phone: (610) 593-1777; Fax: (610) 593-2002
E-mail: Info@schifferbooks.com

For the largest selection of fine reference books on this and related subjects, please visit our web site at **www.schifferbooks.com**
We are always looking for people to write books on new and related subjects. If you have an idea for a book please contact us at the above address.

This book may be purchased from the publisher.
Include $5.00 for shipping.
Please try your bookstore first.
You may write for a free catalog.

In Europe, Schiffer books are distributed by
Bushwood Books
6 Marksbury Ave.
Kew Gardens
Surrey TW9 4JF England
Phone: 44 (0) 20 8392 8585; Fax: 44 (0) 20 8392 9876
E-mail: info@bushwoodbooks.co.uk
Website: www.bushwoodbooks.co.uk

Copyright © 2009 by Steve Larese
Library of Congress Control Number: 2009930591

Designed by John P. Cheek
Cover design by Bruce Waters
Type set in Humanist 521 BT

ISBN: 978-0-7643-3337-8
Printed in China

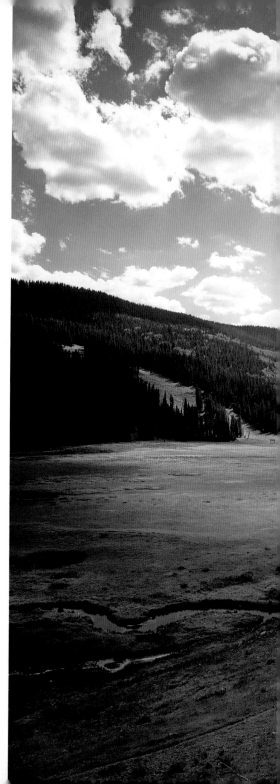

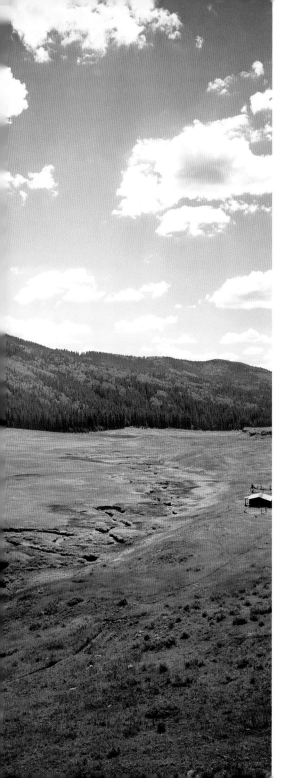

INTRODUCTION

You've picked up this book because you love Durango; so do I. Ever since I first camped here as a boy with my parents and brother, our Chevy Citation was as good as any Conestoga wagon that brought countless settlers west. As a youth, Durango, Colorado, was all cowboys and Indians to me, an impression the tourist industry fueled with its cap guns and chicken feathers. But as I grew and developed an appreciation for its true history, I realized that Durango was more about Victorian grace, economic boom, the Ute Nation, unparalleled beauty, and a respectful, carefree, can-do spirit that continues to enrich everyone Durango enchants.

Of course, Durango had its share of cowboy swagger—even a gunfight or two. Acting Marshall Jesse Stansel shot and killed Sheriff William Thompson in January 1906, when Thompson drew down on him after a morning of drinking at the local saloons. Seems Thompson was sore that Stansel had beat him in a local election and accused him of taking bribe money. Both men were shot, then beat each other with their emptied pistols before collapsing. Stansel turned himself in and was later acquitted of murder for acting in self-defense.

And there was the Stockton Gang—a group of cattle rustlers who'd steal from ranches in nearby Farmington, New Mexico, and take them to their butcher shop in Durango, where the town folk thought they were prosperous ranchers. Durango's opinion of the Stockton Gang changed on April 16, 1880, when a vigilante group from New Mexico came to Durango hunting the cattle rustlers; a rifle shootout erupted in the streets. Durango ran the exposed cattle thieves out of town to Silverton, where betrayal and the law were finally their downfall.

But these sagas of bullets and badges don't define Durango as they do other iconic Western towns. Durango was made for the railroad, and today the railroad makes Durango.

Durango as we know it was incorporated in 1881. Miners were striking it rich in Silverton as early as 1860, 40 miles north up the Animas River Valley, and a means to remove the riches was necessary and profitable. The Denver and Rio Grande Railroad

laid tracks from Durango to Silverton to haul ore to Durango's smelters, where the processed minerals were shipped to the rest of the country. Because of the rugged terrain, a narrow- gauge railway was built. The distance between tracks was 36 inches, as opposed to the 56 inches on standard tracks. The smaller tracks were lighter, cheaper, and better suited to navigate the mountainous terrain.

All of this was the brainchild of General William Jackson Palmer, a railroad civil engineer who became secretary to the president of the Pennsylvania Railroad Company. He served as a Union general in the Civil War, and afterward he donated generously to education funds for former slaves. His namesake hotel, the General Palmer, is still a favorite of guests in downtown Durango. As a young civil engineer, Palmer studied the narrow gauge trains of Great Britain. After the war he founded the Denver & Rio Grande Railroad, with hopes of eventually connecting it with Mexico (hence Durango's name, after the mountainous Mexican state). Seeing the need for a mountain railroad to haul ore from booming Silverton, the D&RG established Durango in 1880, and the first train arrived in town on August 5, 1881. Eleven months later, narrow gauge tracks reached Silverton and the towns were connected. In 1893, ten of Silverton's largest mines closed when silver prices plummeted from $1.05 an ounce to 63 cents an ounce. By then, however, Durango was enjoying a diverse economy, railroad access, and even the beginnings of tourism. The tourist trade was firmly established by the Mesa Verde National Park (established in 1906 by President Theodore Roosevelt) and the San Juan National Forest, a year before. Soon the treasure the railway was hauling was tourists' money. At its beginning, larger Silverton created Durango; today Durango's tourism keeps smaller Silverton alive.

As the 20th century approached, Durango embraced the color and class of the Victorian era. Plush hotels were built that still stand today. The downtown retains its turn-of-the-century charm and local shops, despite several devastating fires, most recently in 2008. Classic Victorian homes still line Third Avenue, which is now a National Register Historic District. Early bicycles quickly found Durango, and they have never left. The train kept rolling and became a National Historic Landmark in 1961. When Denver & Rio Grande Western sold the rail line in 1981, the spur between Durango and Silverton became the Durango & Silverton Narrow Gauge Railroad, one of the few

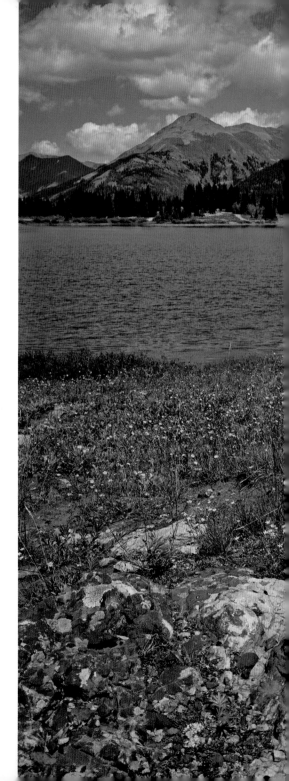

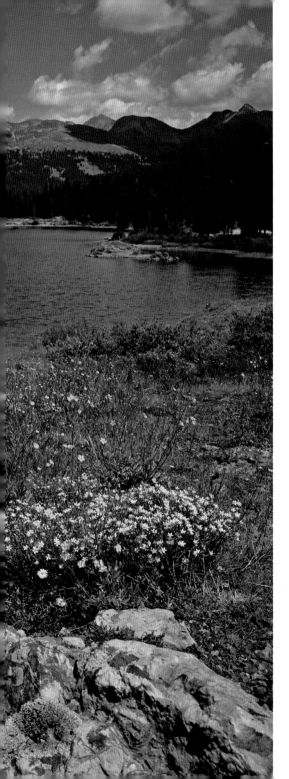

railroads in the world that has run steam engines continuously since 1881.

Purgatory Ski Area opened nearby at Hermosa Park in 1965, and Durango's reputation for outdoor recreation was solidified. The creation of two skiing enthusiasts — Forest Service employee Chet Anderson and oilman Ray Duncan— Purgatory is named for a nearby tributary to the Animas River and is a play upon the story of Spanish explorers who drowned; their bodies were never found but their souls were relegated to Purgatory in Catholic belief. Today the ski area is officially the Durango Mountain Resort, but locals will forever call it Purgatory.

The train begat another outdoor recreation tradition for which Durango is known internationally. In 1971, bicycle enthusiast Tom Mayer challenged his older brother, locomotive engineer Jim, to a race. As the train passed the Mayers' house, Jim blew the whistle and Tom was off on his 10-speed bike. After several races, Tom finally beat the train into Silverton, to his brother's awe, and all of Durango knew of his bragging rights. The following year, in 1972, 36 riders rode in the first Iron Horse Bicycle Classic. Today, registration in the citizens' tour is capped at 1,200 riders and Memorial Day weekend sees a full schedule of competitive and zany bicycling events. Durango loves a good party, and has one almost every month of the year, from January's Snowdown to December's Holidazzle.

Fort Lewis College, a former U.S. Cavalry outpost, became an Indian School in 1891. It went on to offer four-year bachelor degrees in 1964, making Durango a college town as well, offering area Native Americans close access to higher education.

Before all of this, the region was home to the ancestral pueblo Indians who built incredible cliff houses at nearby Mesa Verde and a mesa-top city at Chimney Rock a millennia ago. The region was later and still is home to the Ute Nation, whose federally recognized home and hunting grounds were illegally taken over by miners. Great Ute chiefs, such as Ouray and Buckskin Charley, led their people through difficult times and were ultimately responsible for a peaceful outcome. Today, the Southern Ute Nation is strong in nearby Ignacio. It continues to develop its economy with its casino, resort, and other enterprises.

The aspects of community and beauty that attracted people to Durango a century ago still bring people here to play and live. Today, I revel in taking my daughter

to the Fourth of July picnic and watching her ride her bike down Main Street during May's Iron Horse weekend. She's learning to fish the Animas, hike the Weminuche Wilderness, ski Purgatory, mountain bike the San Juans, and lay pennies on the tracks for the locomotives to flatten, just as I did at her age. The train whistle is becoming an instrumental soundtrack to her life, as it has to the other 15,500 people who call Durango home.

I hope the images in this book help you visit this beloved town no matter where you hang your hat and remember the fresh mountain air of Durango, Colorado.

View of Durango looking north, circa 1875.

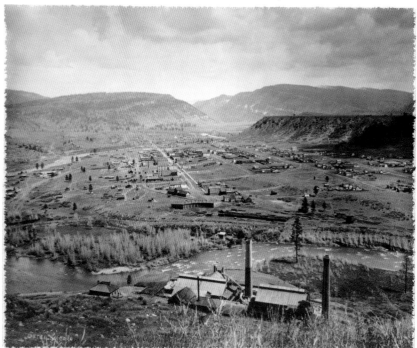

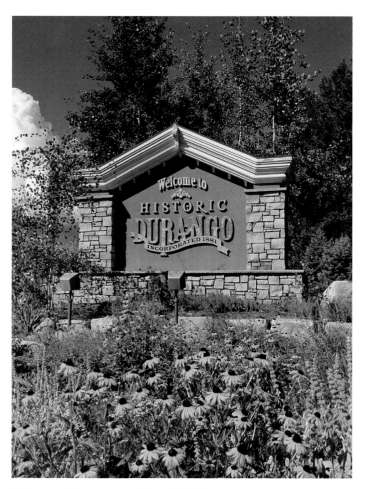

Welcome to Durango, population 15,500.

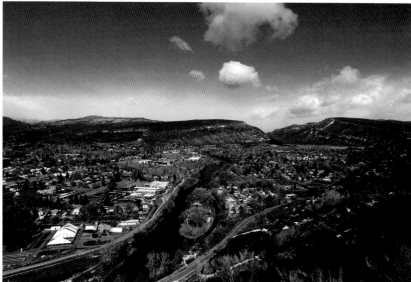

North view of Durango today, from Fort Lewis College.

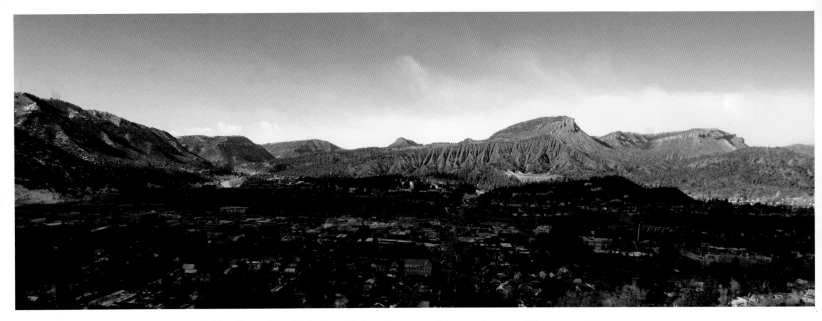

Durango is nestled in the Animas Valley, formed by the Animas Glacier that covered the area between Silverton and Durango two million years ago. The 40-mile-long glacier carved the Animas Valley to its bedrock, resulting in the U-shape of the valley.

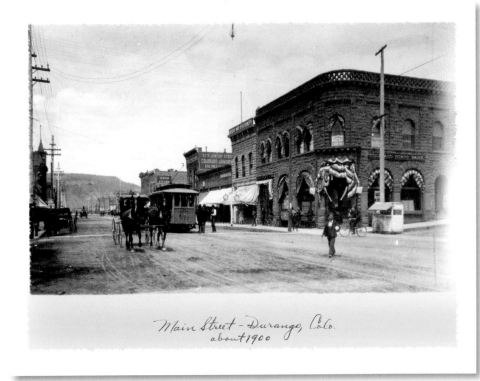

*Main Street - Durango, Colo.
about 1900*

Main and 9th Streets looking north, circa 1900. The Colorado State Bank (far right), Richey's Store, and Sam Wall Drug Store are prominent businesses on the east side of the street. The west side of the street, cropped out by the photographer, was Durango's Saloon Row. Respectable Victorian-era women did not walk on that side of the street. The trolley car is electric, though the buggies visible are horse-drawn. The Colorado State Bank thrived from 1892 until its failure during the silver crash of 1907.

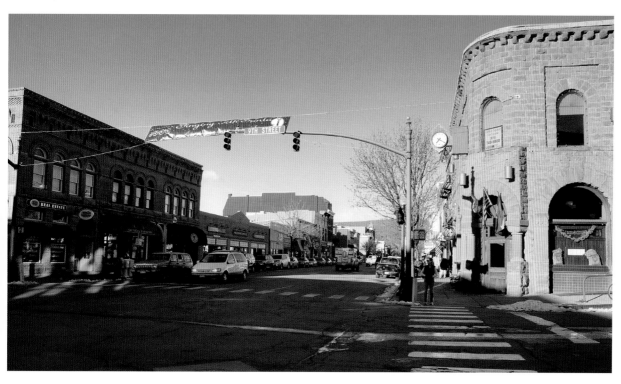

Main Street and 9th today. The Romanesque-style building that was once the Colorado State Bank became, in 2008, the Irish Embassy Pub, showing saloons are doing well on both sides of the streets in Durango today.

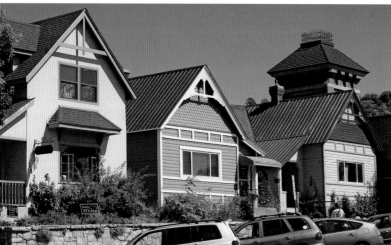

Victorian-style homes along 7th Street still retain the charm and bright colors popular since the 1880s.

Durango has utilized public transportation since the 1880s, first with horse-drawn trolleys, then overhead electric, and today buses that retain the historic trolley look.

As it has for more than a century, the Durango & Silverton train heads back to the depot, past the General Palmer Hotel, built in 1898 at Main and 5th.

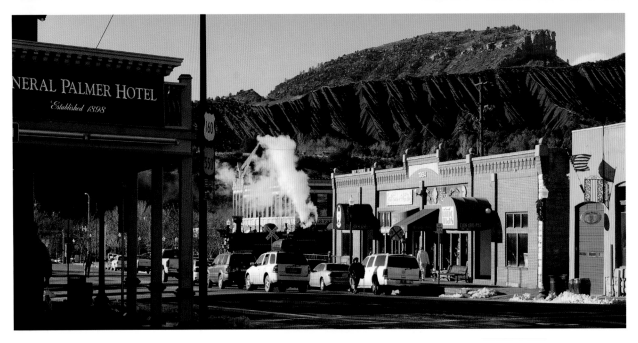

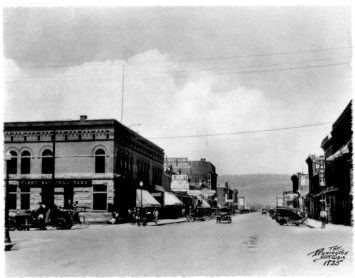

Main and 9th Streets, west side of the street, 1925. The oldest bank in southwestern Colorado, the First National Bank of Durango, operated here from 1882 to 1980. The elaborately detailed Queen Anne brickwork building seen here, with Romanesque sandstone arched windows, was built for $18,219 and replaced an earlier frame building that burned in 1892.

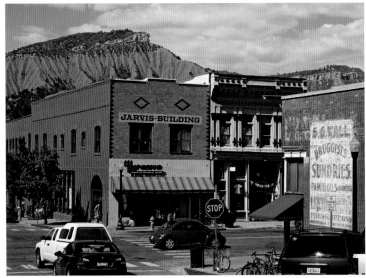

At Main and 10th, the Jarvis Building housed the Gem Theater in 1915. Next to it, the cast iron and pressed metal front of the building came to Durango by train and was considered fire resistant at the time, and less expensive to produce. Across the street, the original sign for the Wall Drug Store is still visible.

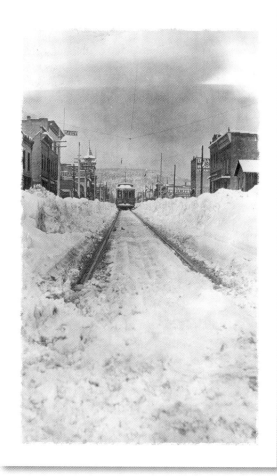

The electric grid for Durango's trolleys is visible in this image, circa 1910, looking north from Main and 6th. The Strater Hotel is seen at the end of the street to the left of the trolley. With Durango's heavy snows, the trolley was often the only means of transportation along Main Street.

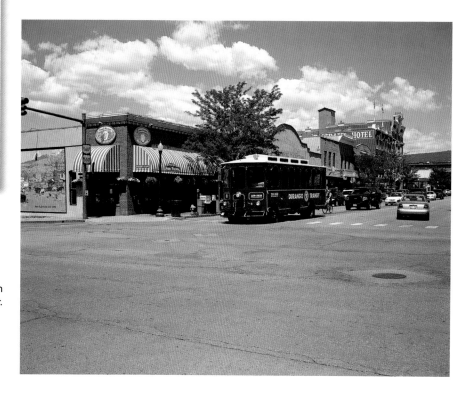

A view today from Main and 6th Streets in warmer weather.

The D&RGW #470 – the San Juan Express – departs from the Durango Depot downtown with passengers for Alamosa, Colorado, circa 1940. Engine #470, built by the American Locomotive Co. in New York, was the first of ten Class K-28 locomotives delivered to Durango in 1923. Three of these engines still run in Durango. The engine shown was requisitioned for use on the White Pass & Yukon Railroad in Alaska during World War II and was scrapped in 1946.

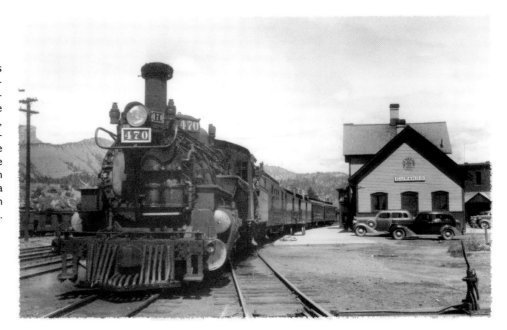

Tourists unload after a trip to Silverton. The depot has changed little over the years.

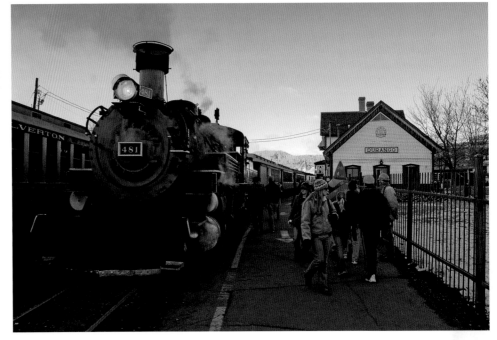

Patrons of the now-defunct Koshak Saloon, circa 1890. Notice the portrait of President Lincoln on the mirror to the right of the bartender. The west side of the 900 block of Main Street was the infamous "saloon district" of Durango. Gambling halls and bars flourished here between 1890 and Prohibition. Ten saloons were located in the district in 1893.

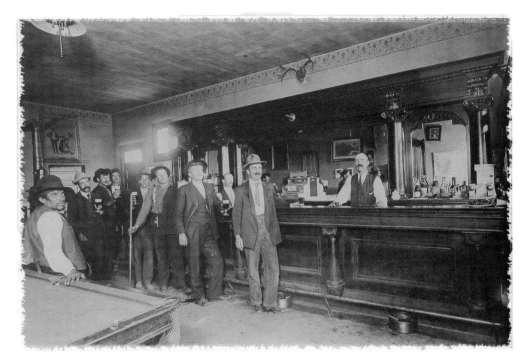

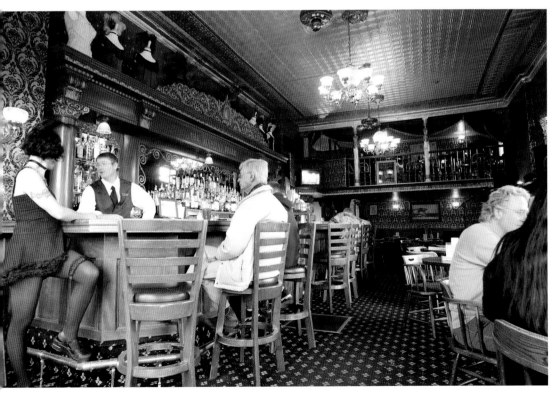

The Strater Hotel's Diamond Belle Saloon today. Though established in the 1950s, the popular saloon and restaurant harkens back to Durango's gartered past.

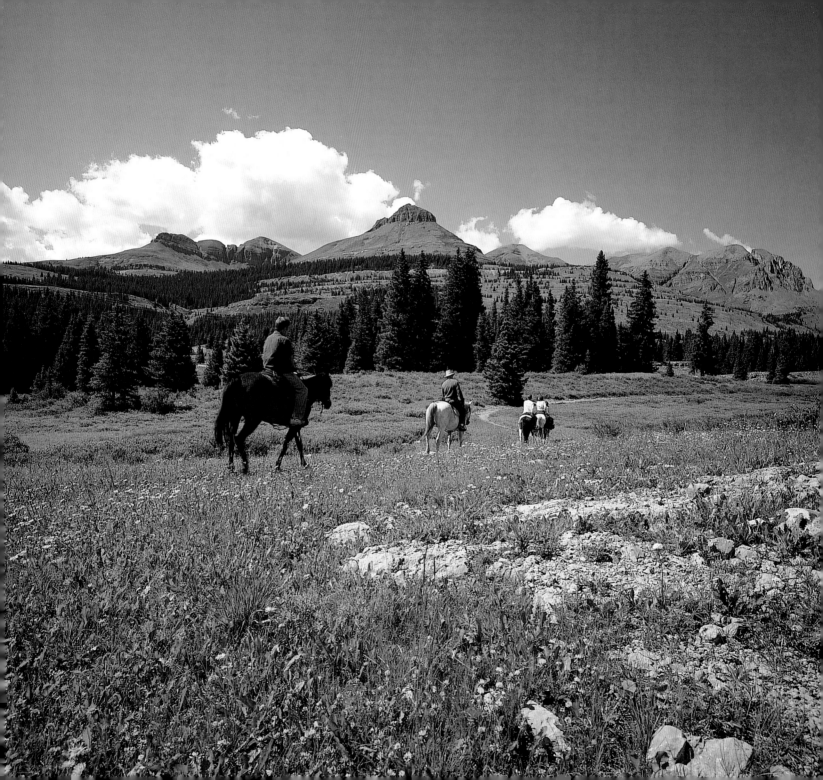

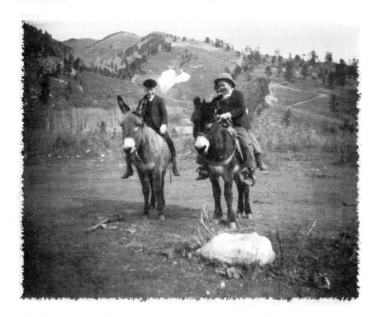

Children enjoy a donkey ride in the mountains north of Durango, circa 1910.

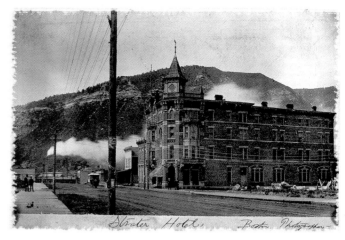

The Strater Hotel looking south, circa 1888, the year of its opening. Notice the horse-pulled trolley. The hotel was built by Henry Strater with railroad wealth, and is an eclectic mix of Italianate, Romanesque, and Renaissance architectural styles. In 1892, Strater built the Columbian Hotel next door, which was later absorbed by the Strater.

The Strater Hotel today, with holiday lights. The telephone poles have been removed from Main Street and, with the exception of the tower on the Strater's right corner, the building remains largely unchanged.

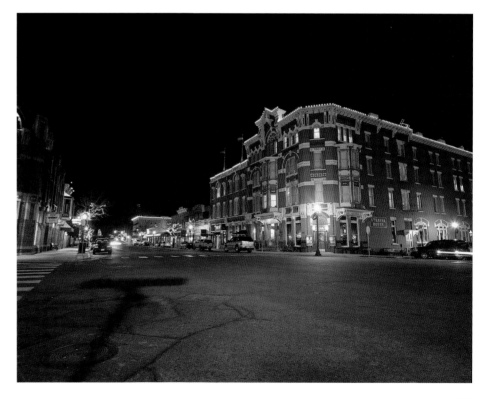

Opposite page:
Tourists today experience happy trails in the Weminuche wilderness near Molas Pass.

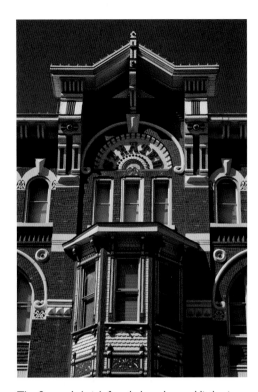

The Strater's brick façade has changed little since its creation.

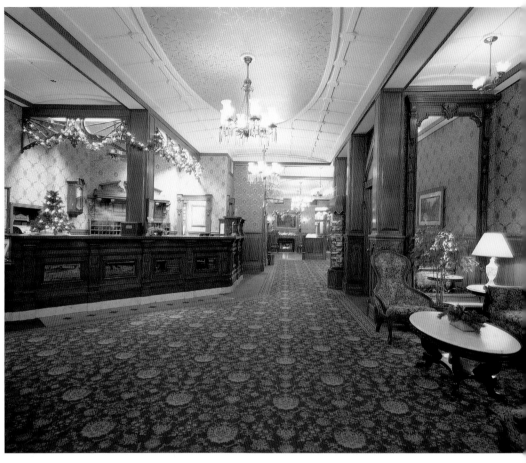

The lobby of the Strater Hotel retains its Victoian elegance.

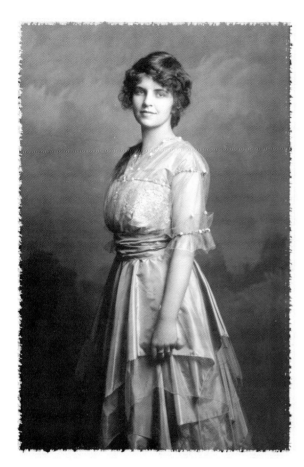

This circa 1890s portrait of Ruth Seavey, the daughter of a prominent Durango family, is typical of Durango's Victorian grace of the time.

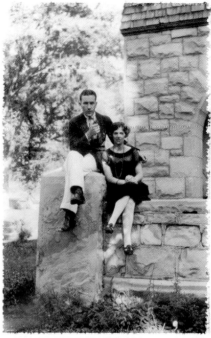

A photogenic Durango couple in the 1920s.

Standing at Main and 10th Streets, these stylish ladies were photographed in the 1920s, sporting flaper-influenced dress.

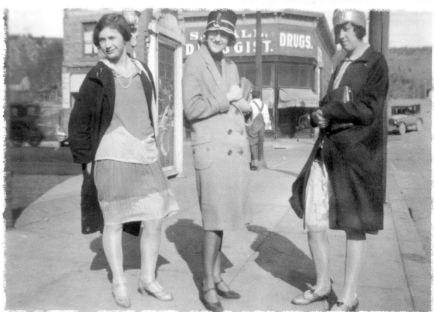

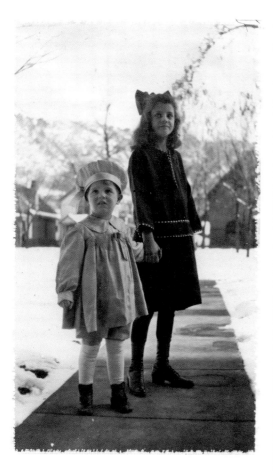

Snapshots of Durango children in the early 1900s.

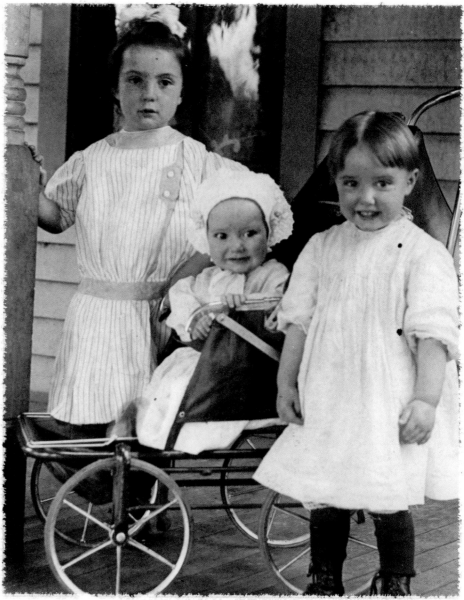

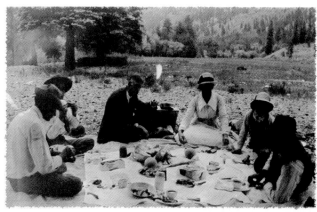

A picnic is enjoyed north of town near Hermosa, circa 1925.

Below:
Ute Indians camp at Main and 7th, circa 1890, with the Strater Hotel in the background. Utes would come into Durango from their reservation in Ignacio, twenty-miles away, to trade and stock up on supplies. The number of Derby hats visible around the teepee suggests the Utes may be selling wares, or the townsfolk are simply curious about their neighbors.

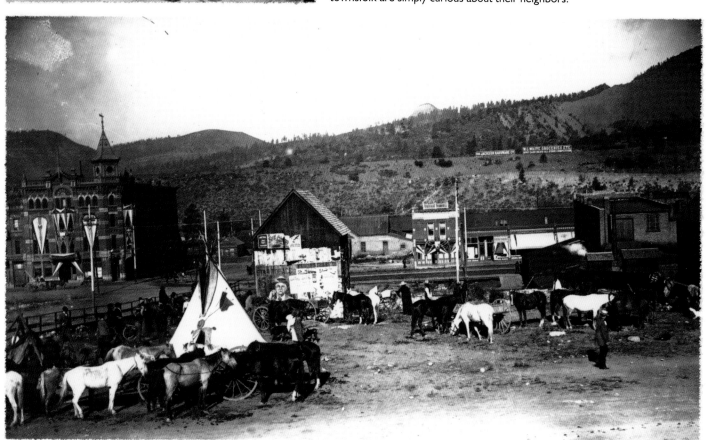

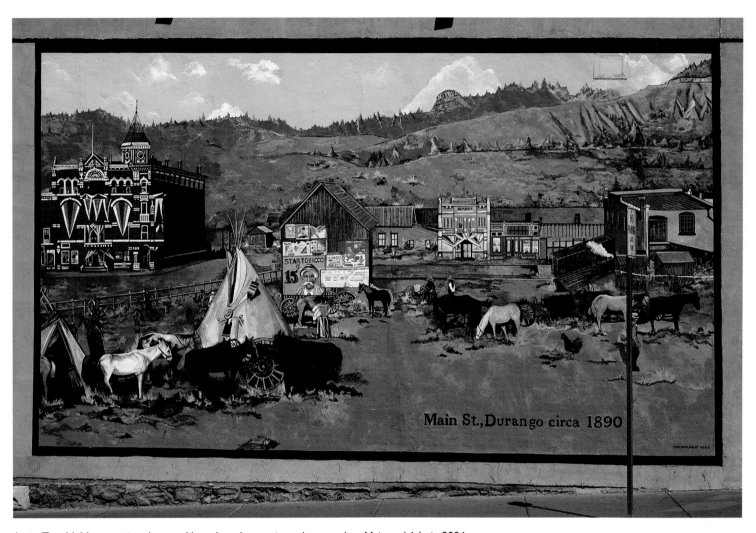

Artist Tom McMurray painted a mural based on the previous photograph at Main and 6th, in 2004.

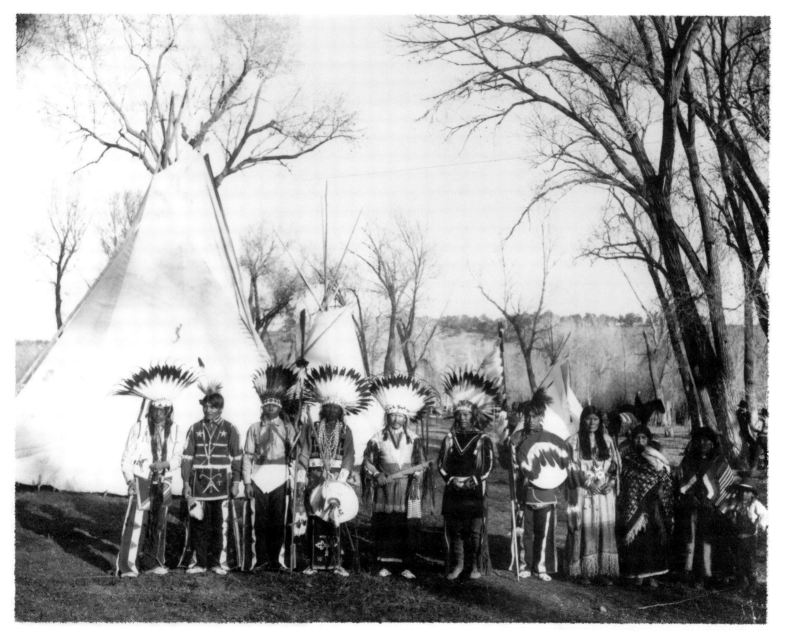

Southern Ute Chief Charley Buck, nicknamed Buckskin Charley, is the fifth from the left in this photograph, circa 1901. Chief Buck was chosen to lead the Southern Utes by Chief Ouray, for whom the town north of Silverton is named. Buck was friends with Theodore Roosevelt and was renowned for his ability to balance the benefits of both white and traditional Ute cultures for his people. Charley's wife, Emma Buck, is eighth from the left. Chief Severo, leader of the Capote Ute band, is sixth from the left. Others are probably members of Buck's family, each dressed in their finest.

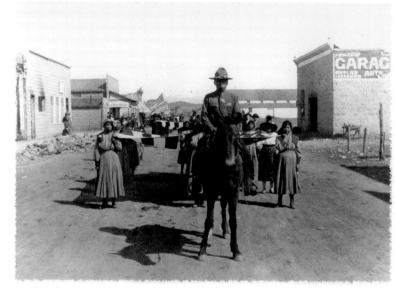

Utes marching in a Fourth of July parade, in Ignacio. The gentleman on horseback appears to be a World War I-era soldier. The insignia over his left pocket signifies the crossed muskets of infantry, though he's riding a horse.

Utes gathered in front of the Southside School (later Longfellow School), circa 1885. The Southside school was Durango's first formal school building and was located between what is now 9th and 10th Streets and 5th and 6th Avenues. The school burned in 1901.

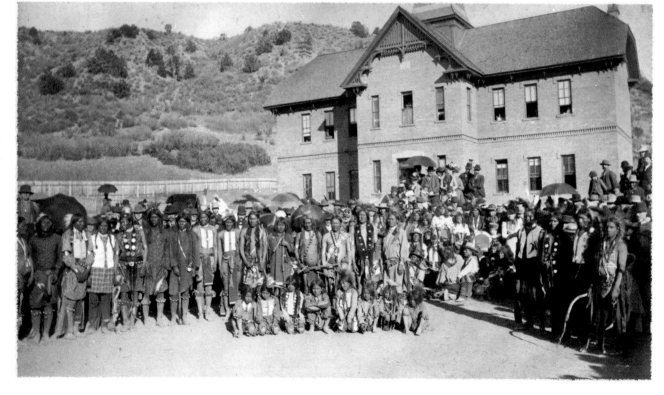

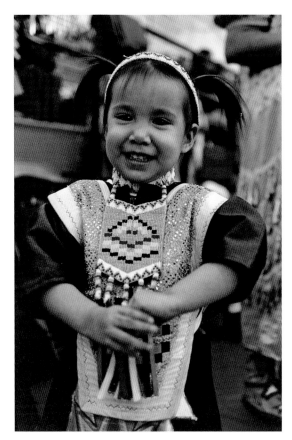

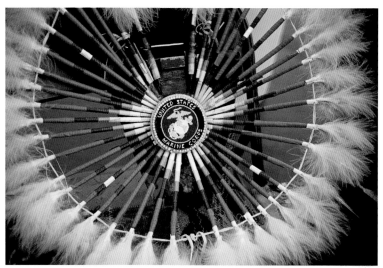

A detail of a fancy dancer's headdress shows the U.S. Marine Corps emblem done in bead work.

A young dancer prepares for Durango's Hozhoni Days Pow Wow, at Fort Lewis College. Begun in 1966, Ho-zhoni Days features three days of inter-tribal dances, art, and native communing annually in March. Hozhoni is a Diné (Navajo) word for "beautiful." In the 1960s, many students at Fort Lewis College were members of the Navajo Nation.

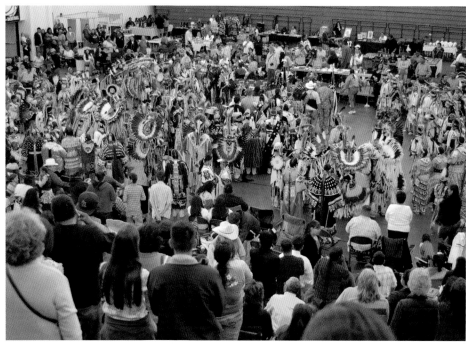

The honor guard presents the colors at the beginning of the 42nd annual Hozhoni Days Pow Wow.

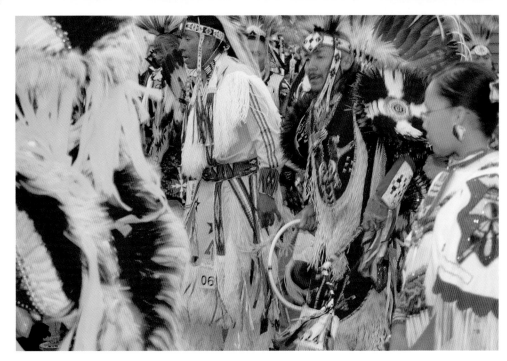

Fancy dancers from a wide range of tribal nations create a blur of color at the Hozhoni Days Pow Wow at Fort Lewis College.

A drum circle provides rhythm for dancers at the Hozhoni Days Pow Wow.

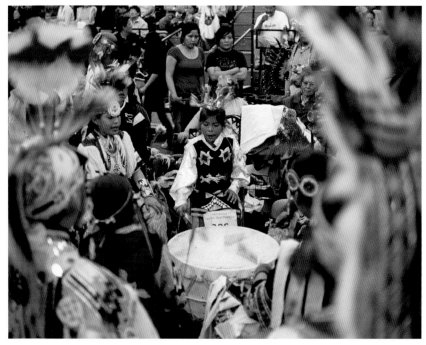

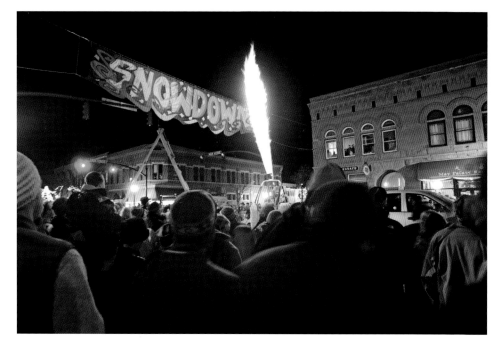

The flame from a balloon burner kicks off the Snowdown parade. Started in 1986, Snowdown is an annual celebration embracing all things snow-related, at the end of January. Residents refer to themselves as "Durangotangs" during this Mardi Gras-like week, which has a different theme each year.

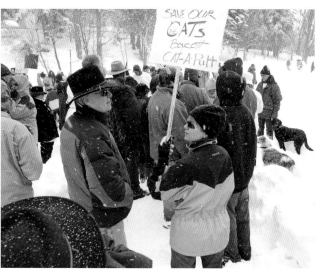

Contestants launch an 8-oz. bean-bag kitty, during the Snowdown Cat-a-pult, in which teams construct and use trebuchets to fling feline bean bags 270 feet into a "kitty box" target at Buckley Park.

Mock protesters support bean-bag kitties during Snowdown's Cat-a-pult. This Snowdown event seems especially popular with dogs.

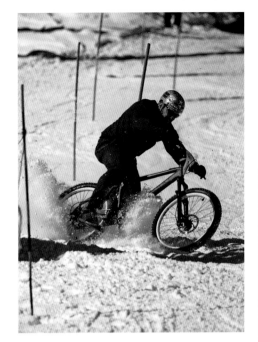

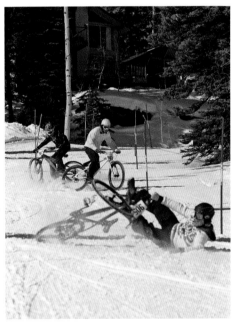

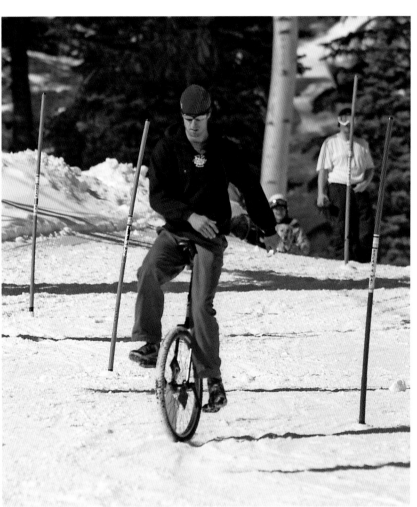

Participants combine their love of mountain biking and slalom skiing at Durango Mountain Resort during a Snowdown competition.

A unicyclist wows the crowd.

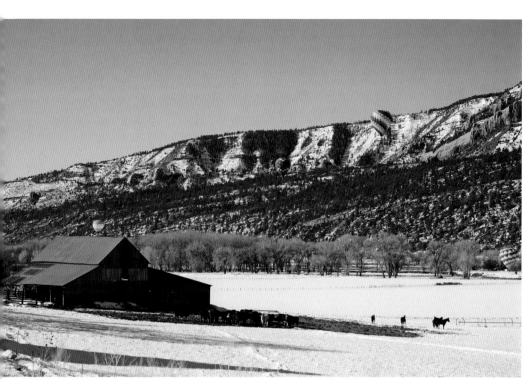

Balloonists enjoy a winter morning's flight over the Hermosa Valley.

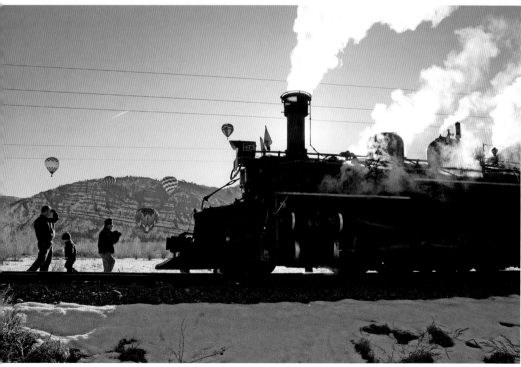

The train stops so passengers can enjoy the balloon lift-off during Snowdown weekend. The train hosts several special tours throughout the year. Call (970) 247-2733 or log on to www.durangotrain.com for schedules.

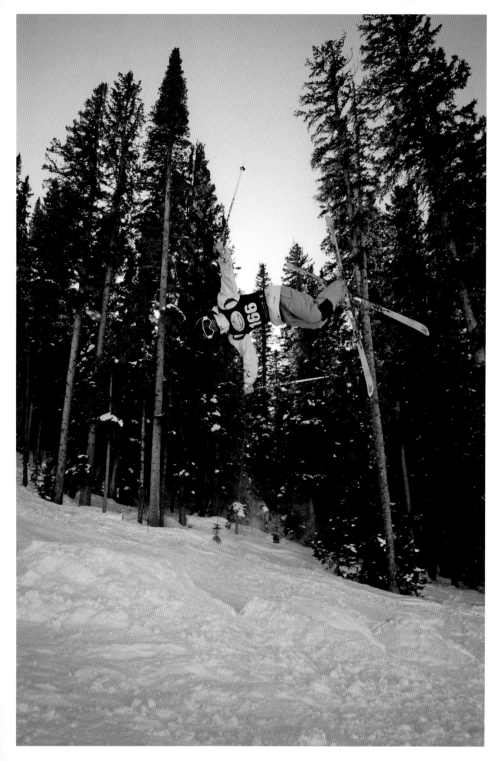

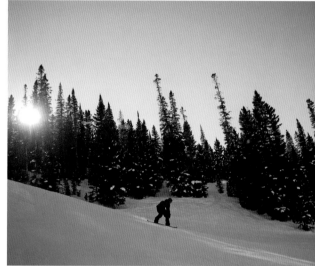

A snowboarder enjoys the slopes at Durango Mountain Resort. The ski area is a family favorite as it offers skiing and snowboarding terrain for all skill levels (www.durangomountainresort.com).

A free-style skier goes big during a regional competition at Durango Mountain Resort.

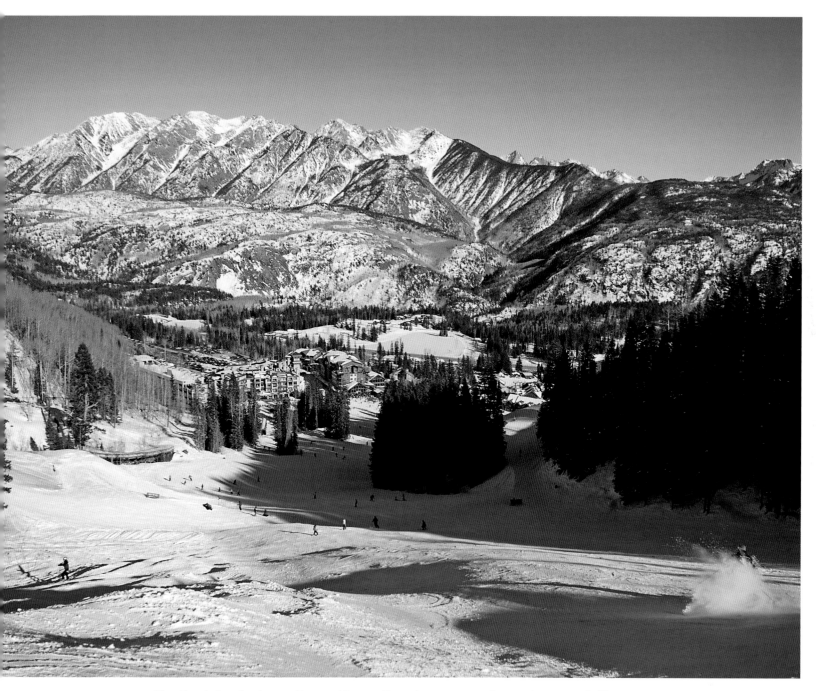

The village below the slopes at Durango Mountain Resort has restaurants, shops. and room rentals. The mountain is open year-round, and has mountain biking, scenic chair lifts, and an alpine slide during the summer.

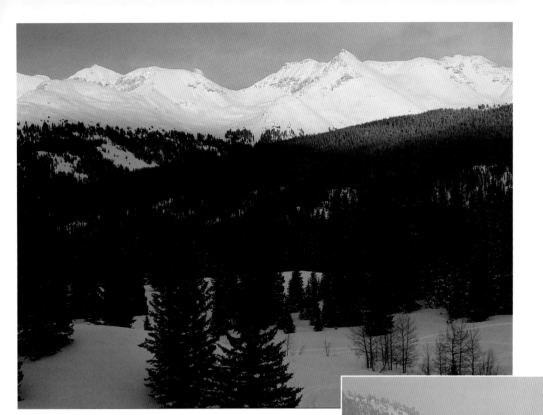

Winter blankets the San Juans north of Durango. This range in the Rocky Mountains covers more than 12,000 square miles, about an eighth of the state. Largely volcanic in origin, the San Juans are rich in silver, gold, and other mineral deposits, which first attracted miners.

The Animas River flows through Cascade Canyon, north of Durango. The Animas begins life north of Silverton near the ghost town of Animas Forks in the San Juan Mountains, flows through the heart of Durango, and eventually merges with the San Juan river near Farmington, New Mexico. It is the last free-flowing river in Colorado. The group Friends of the Animas River (www.animasriverkeeper.org) is devoted to maintaining the health of the river.

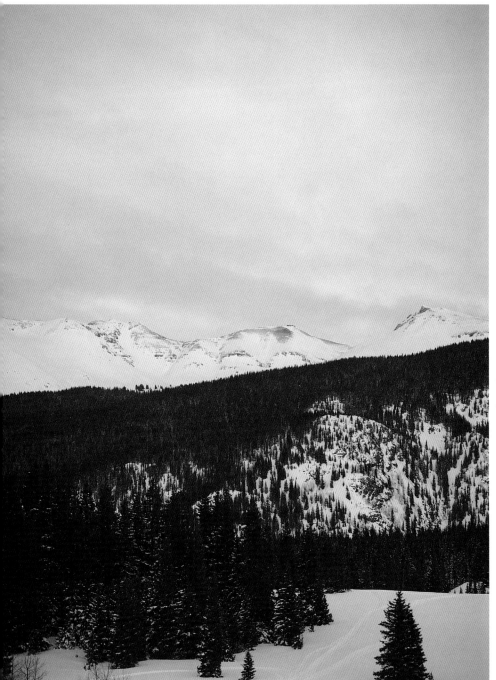

The last rays of the day catch winter clouds near Molas Pass.

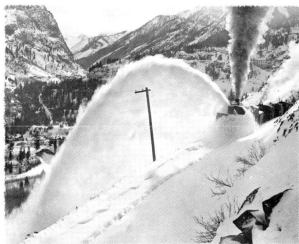

Rio Grande Southern engines push a rotary snowplow to clear deep snow from the tracks north of Durango, circa 1915. The snowplow was steam powered and pushed by the locomotives, three in this image.

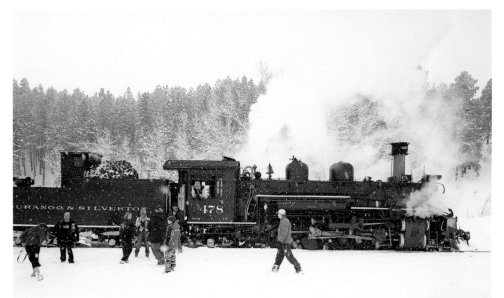

Passengers play in the snow at the Cascade Canyon wye, a turntable where locomotives can be turned around. From mid-November to early May, the Durango & Silverton Narrow Guage Railroad runs an abbreviated trip to Cascade Canyon, as snow makes a full route to Silverton impassable.

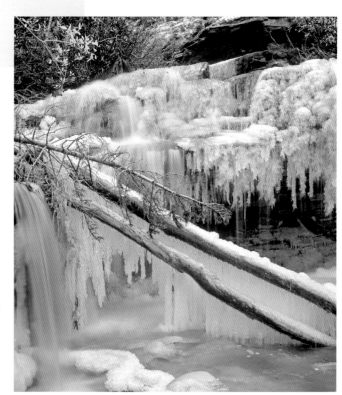

Molas Creek
in winter.

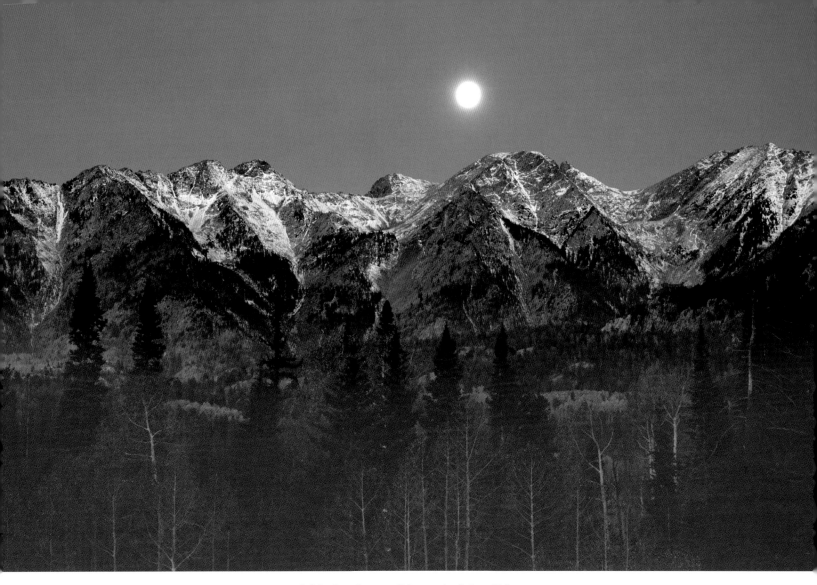

A full winter's moon lights up the Animas Valley.

Far left:
Wheat grass is juiced using pedal power at the Durango Farmers Market.

Left:
A young superhero selects tomatoes at the Durango Farmers Market.

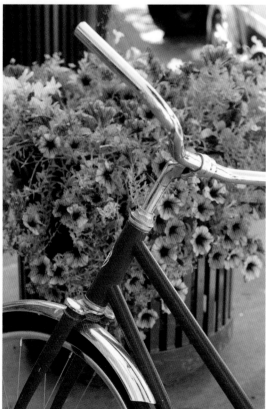

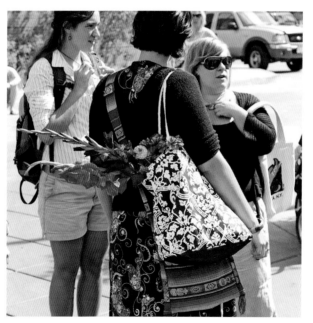

Friends chat at the Durango Farmers Market.

A commuter bicycle outside a downtown shop creates a Durango spring scene.

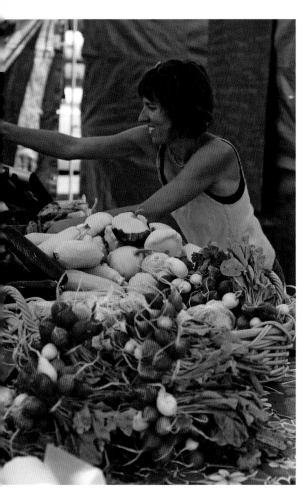

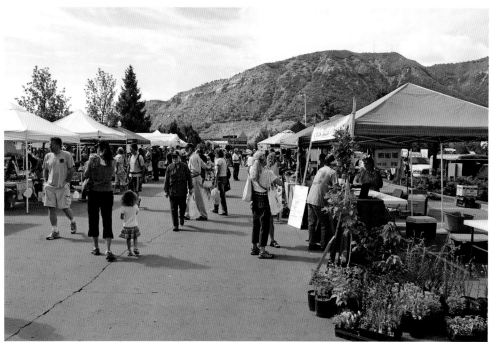

The Durango Farmers Market is every Saturday from May 9 through Oct. 31, 8 a.m. until noon, in the First National Bank parking lot. Area farmers, ranchers, food producers, and crafters sell their wares as local musicians perform and friends catch up. www.durangofarmersmarket.org.

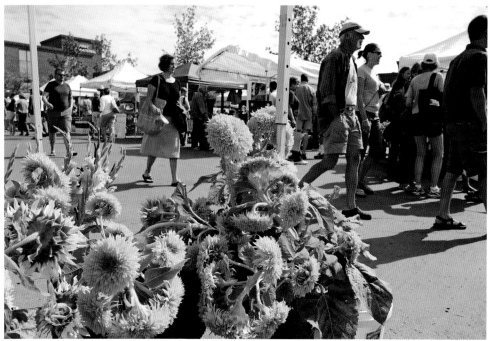

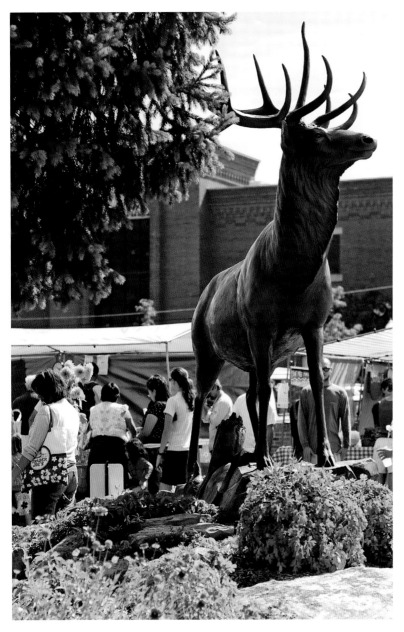

The Exulted Ruler, a life-sized bronze sculpture of a bull elk, by Rip Caswell, oversees the First National Bank of Durango parking lot.

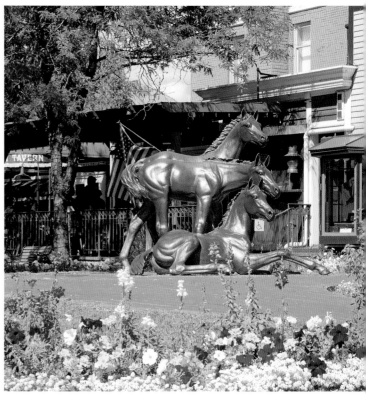

Whinney & Friends, a life-sized bronze sculpture, by Joyce Parkerson, was placed at the corner of Main Ave. and 5th Street in 2001, as part of the City of Durango Public Art Collection. A map showing the location of all the public art in Durango is available at www.durangogov.org.

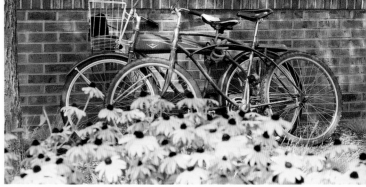

Black-eyed Susans dress up classic single-speed bicycles downtown.

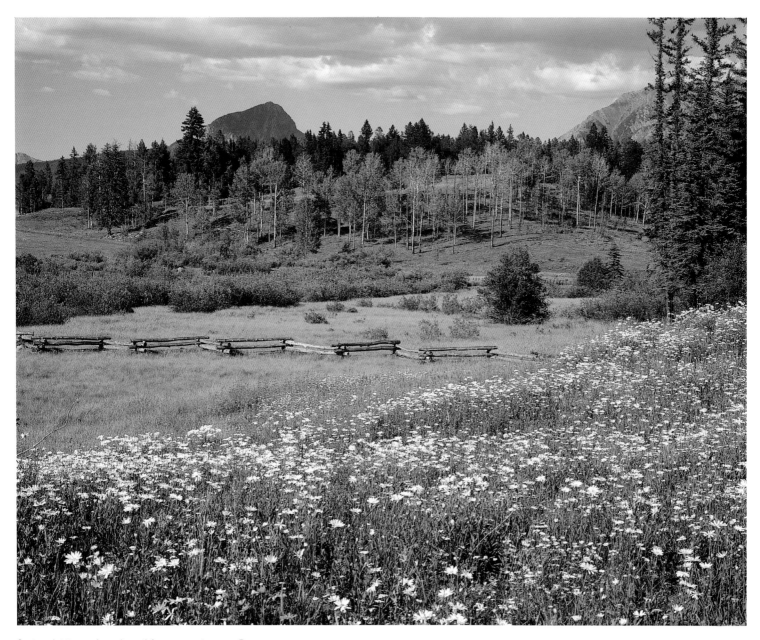

Spring daisies and a split-rail fence coexist near Purgatory.

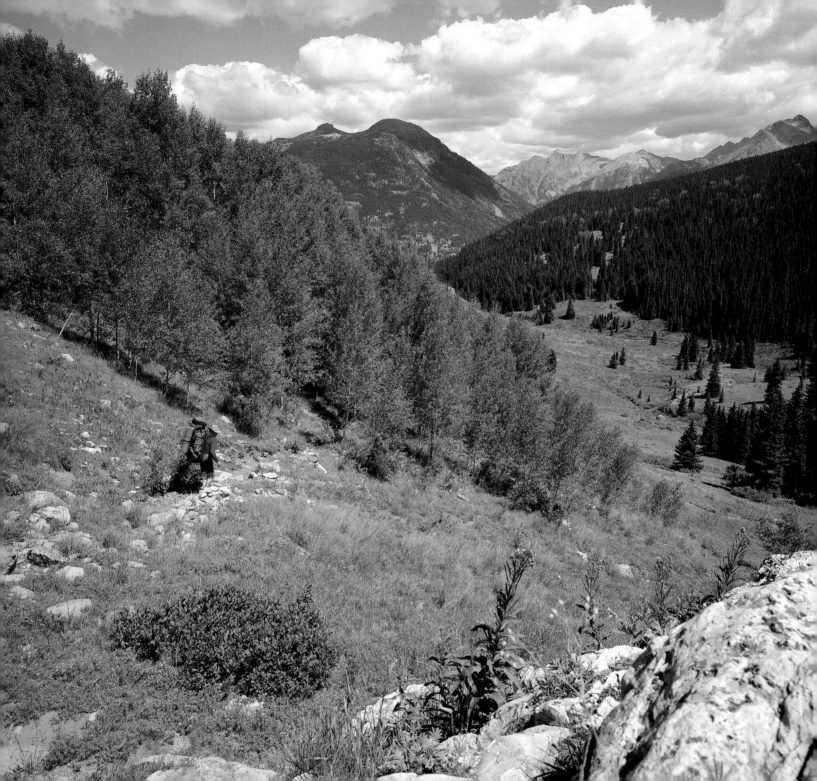

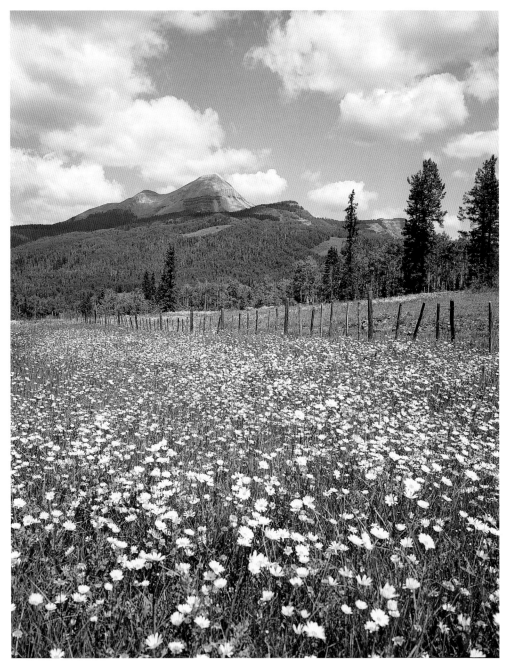

Opposite page:
A backpacker winds through the Weminuche Wilderness between Durango and Silverton. The Weminuche is Colorado's largest wilderness at nearly half-a-million acres, and lies in the heart of the San Juan mountain range.

Engineer Peak in the Spring. The landmark is 35 miles north of Durango and rises 12,968-feet above sea level.

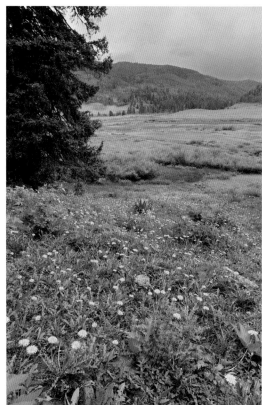

Wildflowers help Hermosa Park live up to its name, which means "beautiful" in Spanish.

39

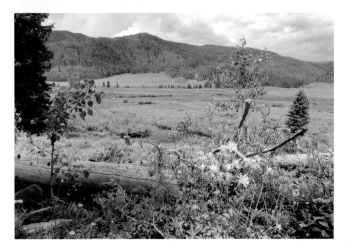

Columbine, Colorado's state flower, grows in the Hermosa Park area behind Purgatory Mountain, 25 miles north of Durango.

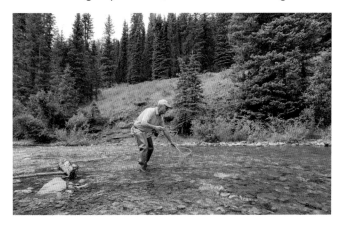

Randy Holt lands a rainbow trout in Upper Hermosa Creek.

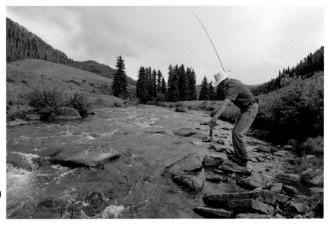

Located 25 miles north Durango, Hermosa Creek is the only basin in Colorado to receive an Outstanding Waters designation outside of a wilderness area or national park. Outstanding Waters represents the highest level of protection for rivers and streams and is designated by the Colorado Water Quality Control Commission.

Richard Larese has success in the Lower section of Hermosa Creek.

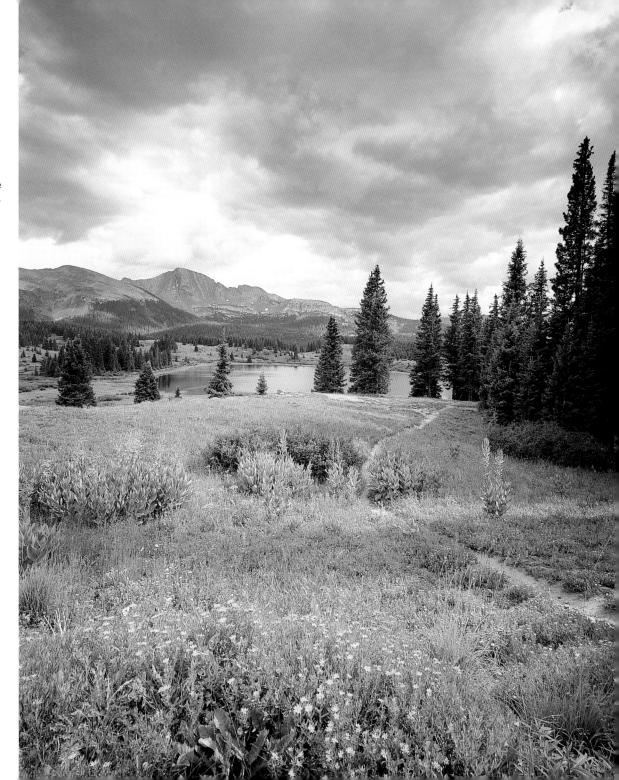

Little Molas Lake
and wildflowers.

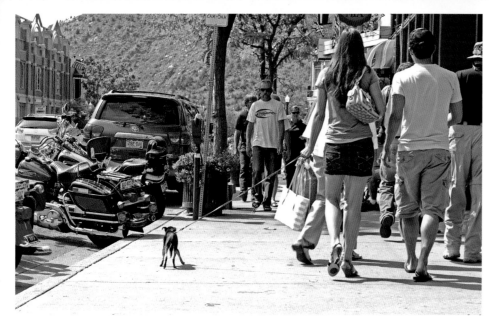

Harleys and handbags share a Durango summer weekend downtown.

Cyclists enjoy a caffeinated break downtown at the Magpie Coffee Shop.

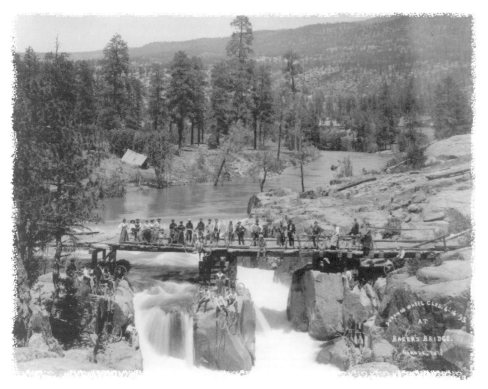

The Durango Wheel Club, 1895, demonstrates Durango's long love affair with the bicycle. This photograph was taken at Bakers Bridge (which no longer stands) spanning the Animas.

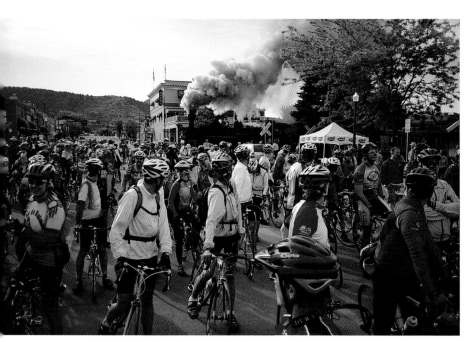

The Iron Horse Citizen's Tour starts with the blow of a train whistle from downtown. In 1971, bicycle enthusiast Tom Mayer challenged his older brother, locomotive engineer Jim, to a race. As the train passed the Mayer's house, Jim blew the whistle, and Tom was off on his 10-speed bike. When Tom eventually beat the train into Silverton, all of Durango knew of his bragging rights, and the following year, in 1972, thirty-six riders rode in the first Iron Horse Bicycle Classic. Today, registration is limited to 1,200 riders for the tour. www.ironhorsebicycleclassic.com.

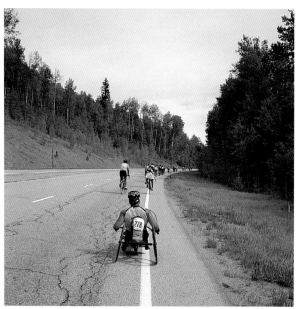

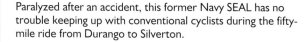

Paralyzed after an accident, this former Navy SEAL has no trouble keeping up with conventional cyclists during the fifty-mile ride from Durango to Silverton.

Durango resident and local celebrity Ned Overend (left) easily cruises the Citizen's Tour of the Iron Horse. Overend was inducted into the Mountain Biking Hall of Fame in 1990 and the United States Bicycling Hall of Fame in 2001. He is world-renowned for his endurance and has earned the nickname "The Lung." To the right of Overend is John Glover of Mountain Bike Specialists.

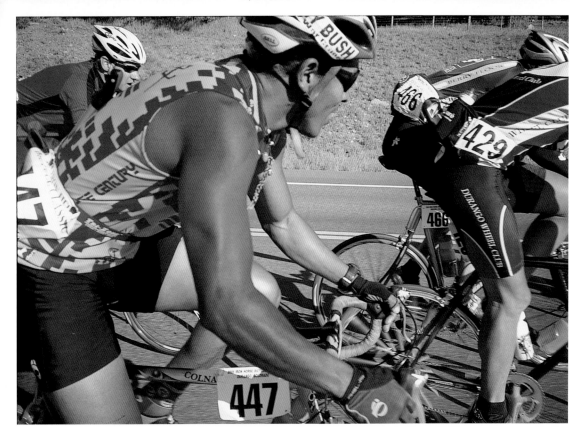

Riders in the men's race vie for position. Unlike the Citizen's Tour, racers go for time and prizes. Pros can ride the fifty miles from Durango to Silverton in about 2 hours; tour riders are given 4 hours and 45 minutes to complete the journey.

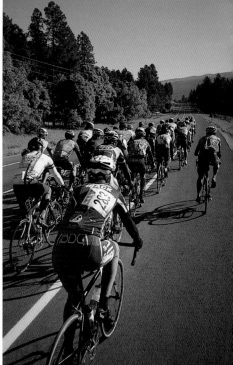

Cyclists form a paleton. By riding in these tight packs, wind resistance is cut down and riders are able to draft those in front.

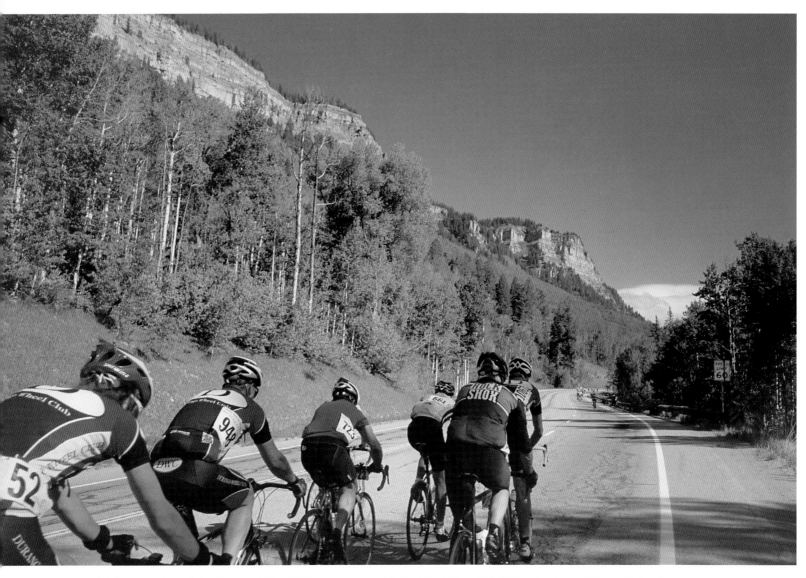

Modern members of the Durango Wheel Club prepare to tackle Coal Bank Pass. U.S. 550 is closed to vehicle traffic for the Iron Horse, affording cyclists a safe and unique ride along one of the country's most scenic and challenging stretches of highway.

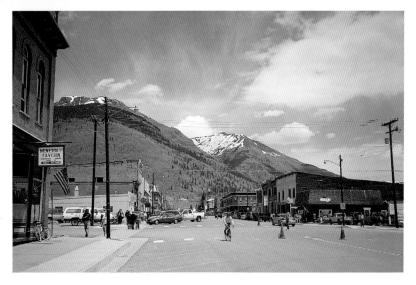

Cyclists enter Silverton having ridden fifty miles after climbing two mountain passes, each at more than 10,000 feet.

Tired and triumphant, tour cyclists cross the official finish line in Silverton.

Cyclists bank at Main and 8th during the women's criterium, a timed race looping through closed-off streets of downtown during the annual Iron Horse, Memorial Day weekend.

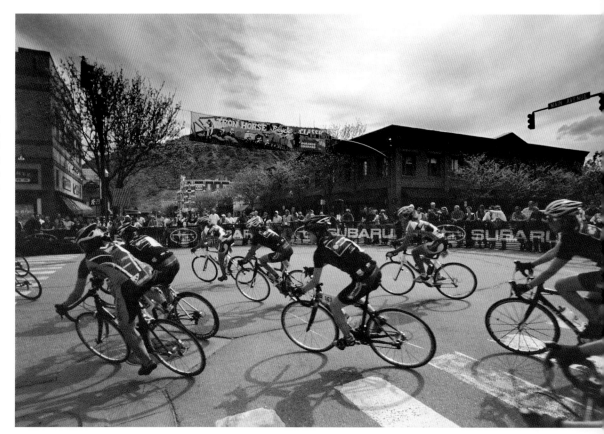

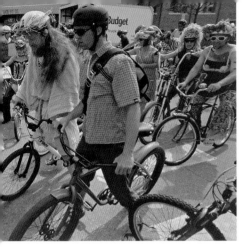
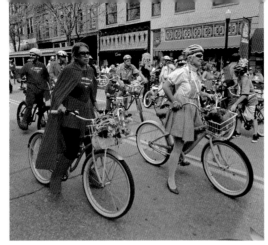
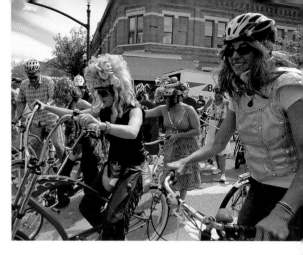
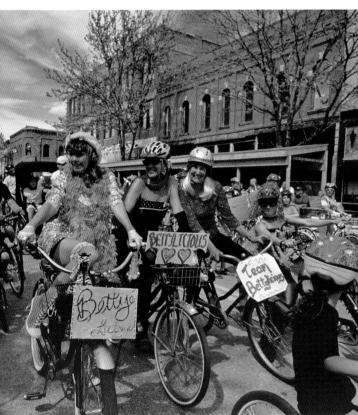
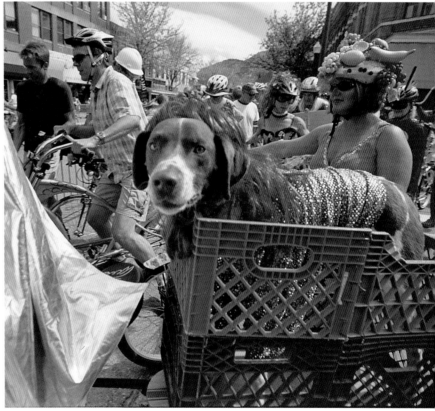

Riders, both human and canine, get ready to begin the "tour de farce" that is the Durango Cyclery Cruiser Criterium, where participants vie for the best bike and costume combination.

47

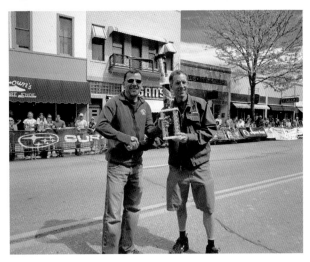

Cycling legend and Durango resident Ned Overend presents the Iron Horse Bicycle Classic trophy to Durango Silverton Railroad vice president Jeff Jackson. The trophy is awarded to the railroad when the train beats the cyclists to Silverton. The year this photograph was taken, 2008, the race to Silverton was cancelled due to a May snowstorm and the train won by default. It is not uncommon to have snow in the mountains well into summer.

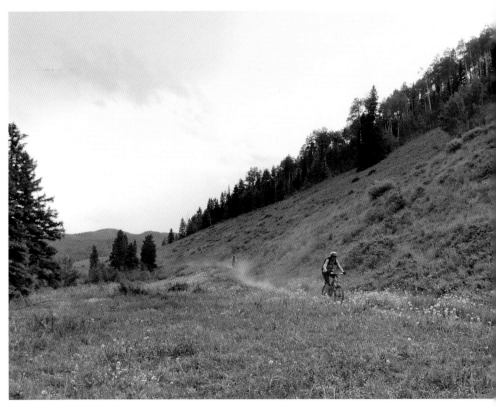

A mountain biker bombs her bike down Hermosa Creek trail, a favorite among the hundred of miles of single track in the Durango area. It begins behind Durango Mountain Resort and travels about thirty miles to Hermosa, just north of Durango.

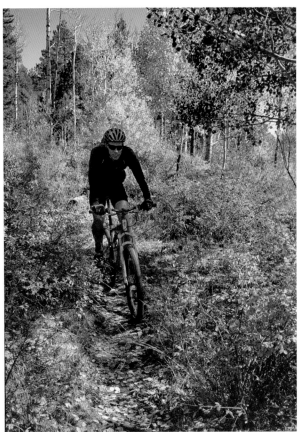

Tom Ober navigates the Junction Creek portion of the Colorado Trail.

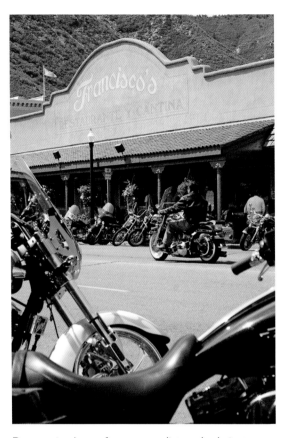

Durango is a haven for motorcyclists and culminates with the Four Corners Bike Rally over Labor Day weekend (www.fourcornersbikerally.com).

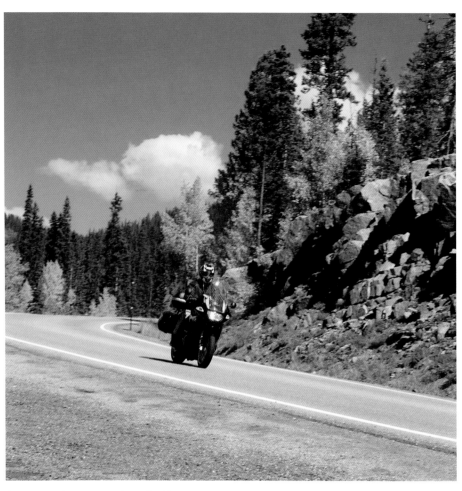

A motorcyclist corners along Coal Bank Pass. Twisty U.S. 550 between Durango and Silverton is a popular, scenic motorcycle route.

Flowing through the heart of Durango, the Animas River is one of the last free-flowing rivers in the United States. It is fed by snowmelt and springs from the San Juan mountains near Silverton and flows into New Mexico's San Juan river. A major element of the Durango community, the river is loved by rafters, kayakers, anglers, and all species of water-loving dogs. Named by Spanish explorers, its full name is El Rio de las Animas Perdidas (The River of Lost Souls). As legend goes, some of the explorers drowned in the river and their bodies were never found for burial.

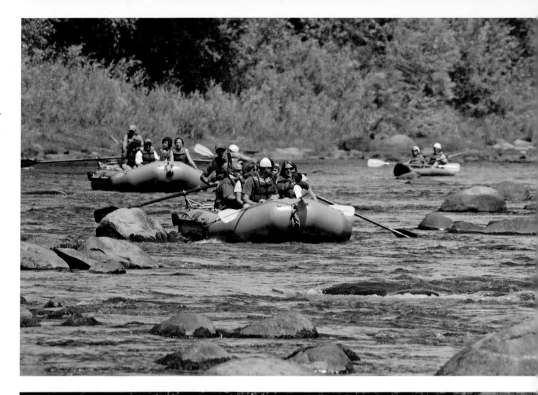

A sport kayaker enjoys some Animas rapids.

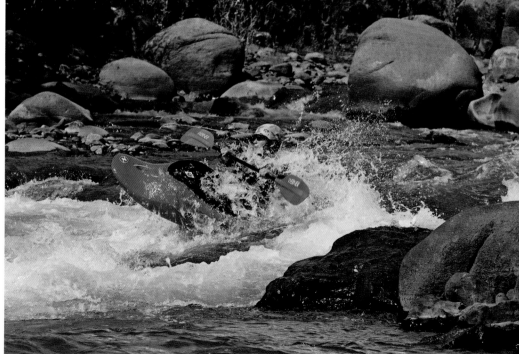

Several rafting companies are available to take visitors on river adventures ranging from mild to wild.

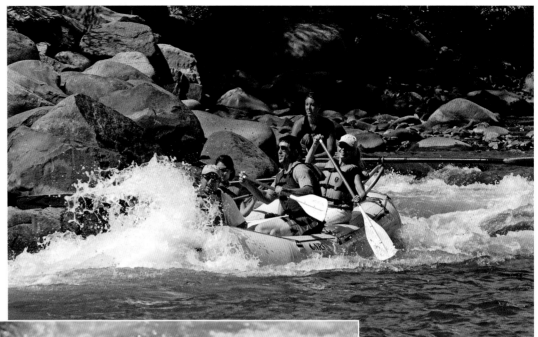

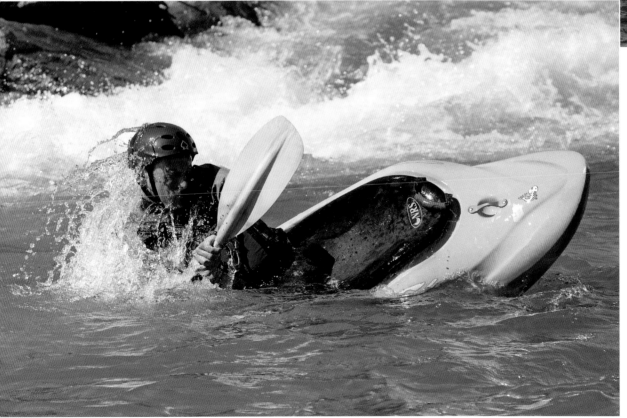

A kayaker pulls out of an Eskimo roll.

A wetsuited water dragon plays in a rapid's current.

A doggie and a paddler enjoy a day on the Animas. Durango is known for its love of canines, and they often accompany humans on a wide range of activities.

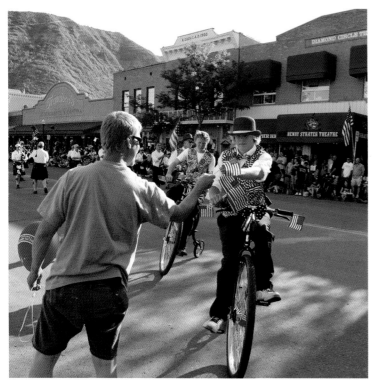

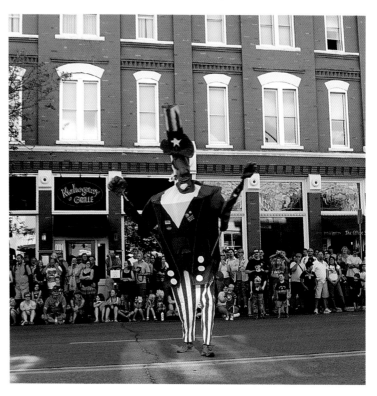

High wheelers pass out flags during Durango's Fourth of July parade down Main Street.

Uncle Sam entertains the crowd during the annual Fourth of July parade downtown.

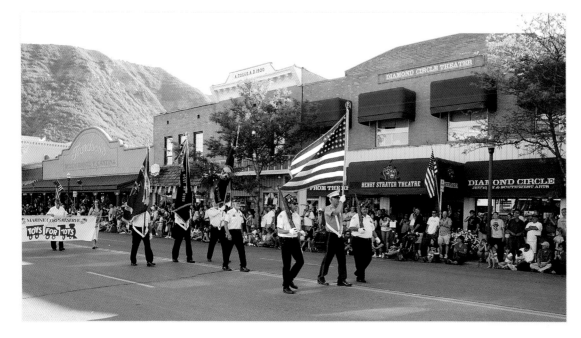

Local veterans lead the Fourth of July parade.

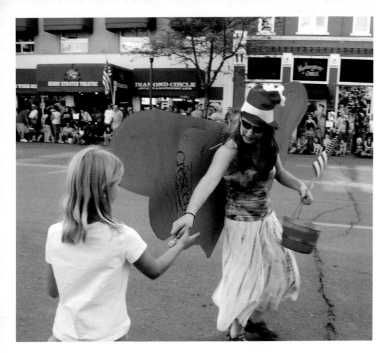

A fairy charms young parade goers.

Riders cowgirl-up for the Fourth of July parade.

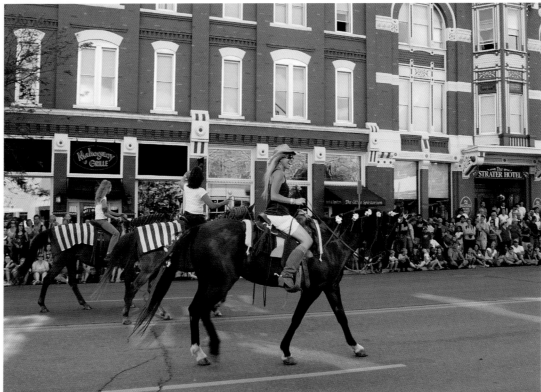

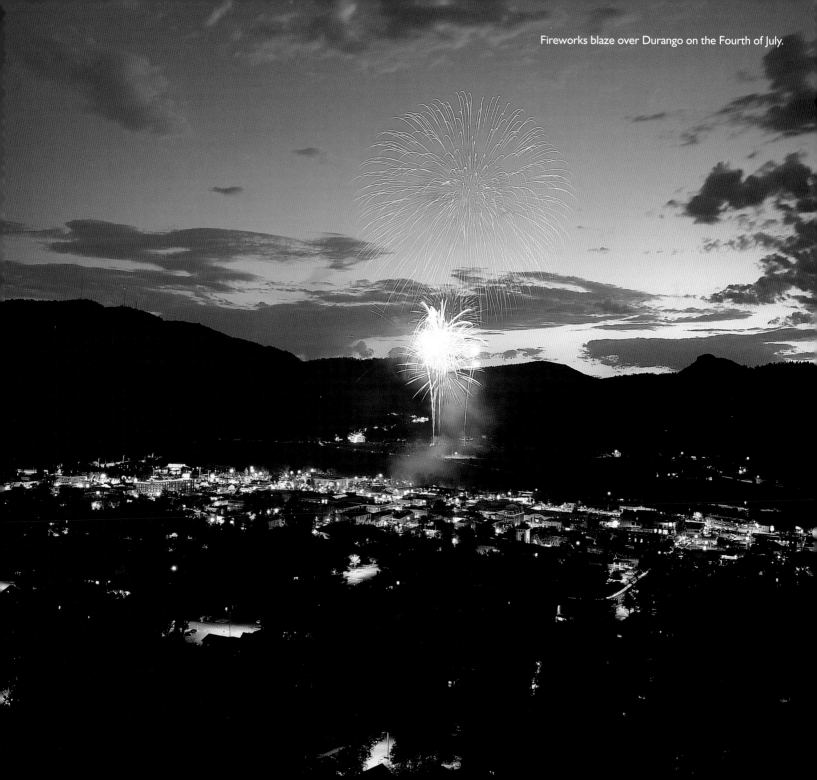

Fireworks blaze over Durango on the Fourth of July.

Despite growth from development, much of the Durango area remains farm and ranch land.

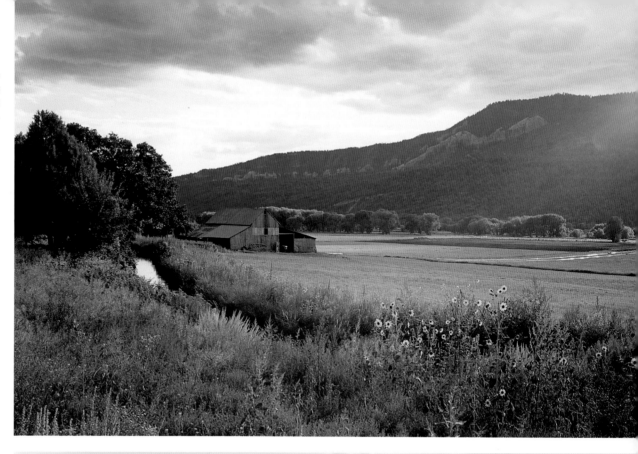

Jerusalem artichokes blanket a field on the mesa above Durango.

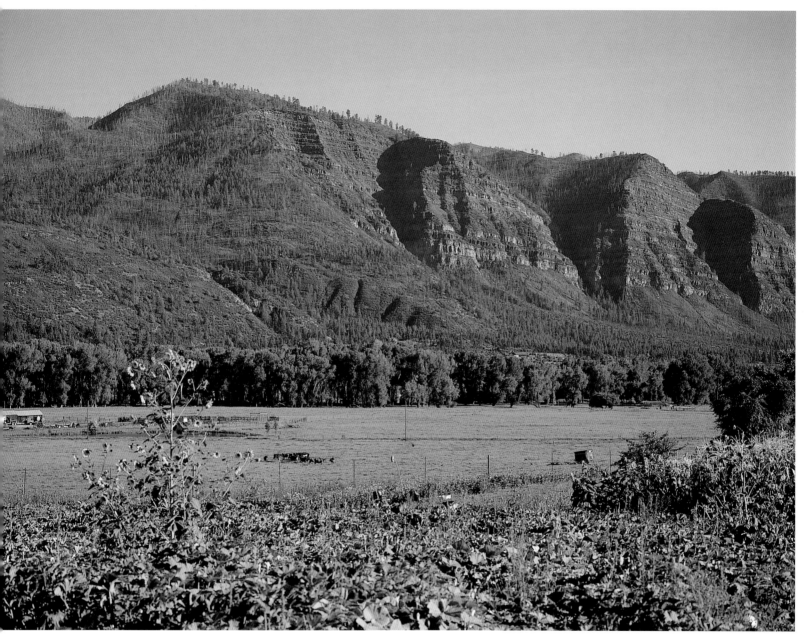

The Hermosa Cliffs rise behind a James Ranch pasture. The family-owned James Ranch is an organic producer specializing in finished beef, artisan cheese, and organic crops (www.jamesranch.net).

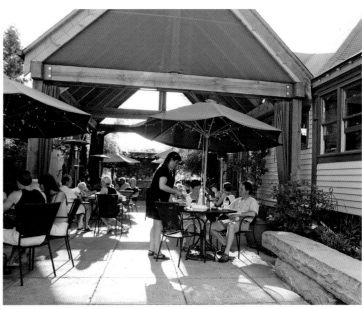

Durango has attracted several notable restaurants and breweries that serve everything from steaks to sushi. It all may be sampled during the Taste of Durango, an annual May event that benefits local food banks (www.tasteofdurango.com).

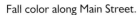

Fall color along Main Street.

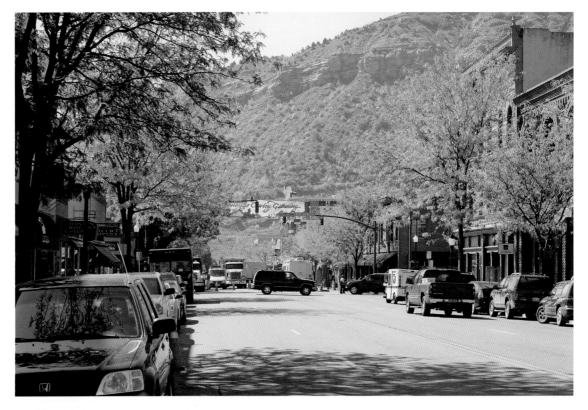

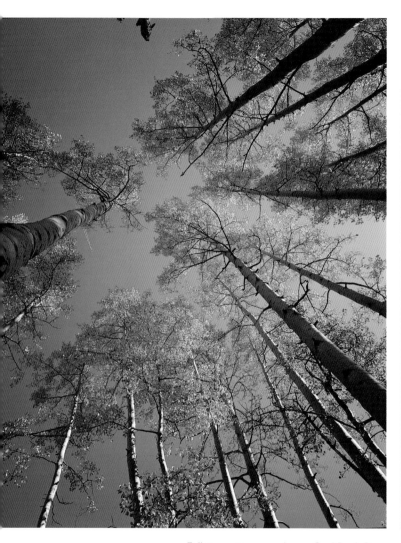

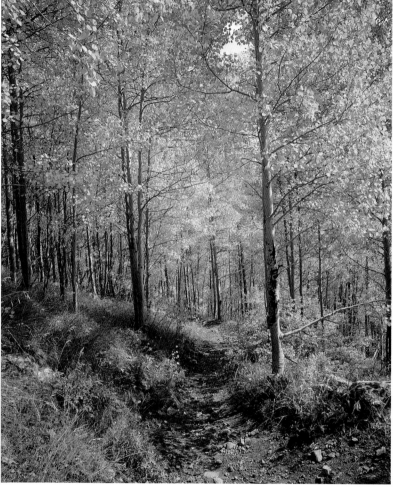

Fall tinges aspens red near Coal Bank Pass. Aspens line a trail in the Weminuche Wilderness.

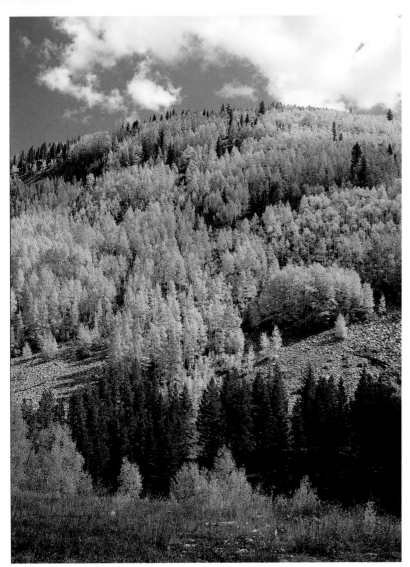

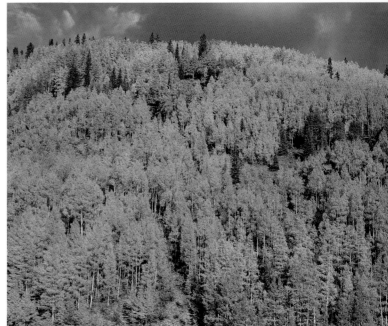

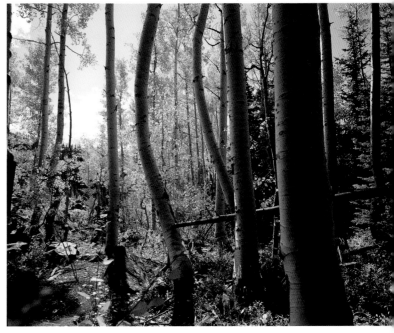

Fall color splashes the mountainsides north of Durango, usually beginning the third week in October.

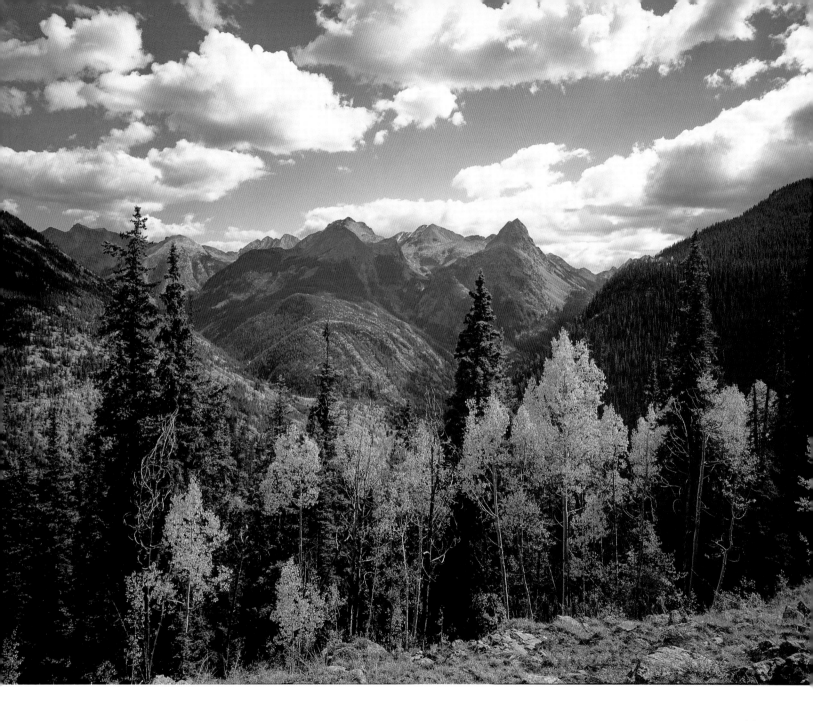

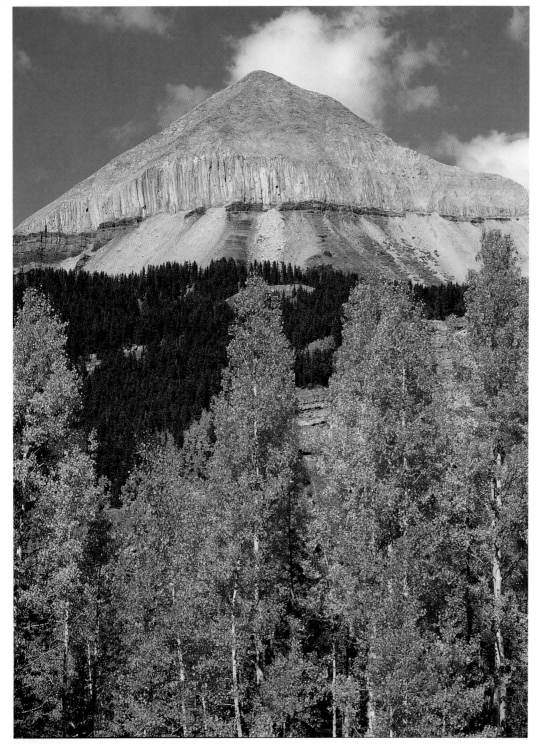

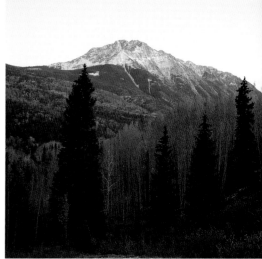

Twighlight Peak as seen from near Molas Pass. The mountain rises to 13,158 feet above sea level.

Aspens take on a reddish hue in front of Engineer Peak.

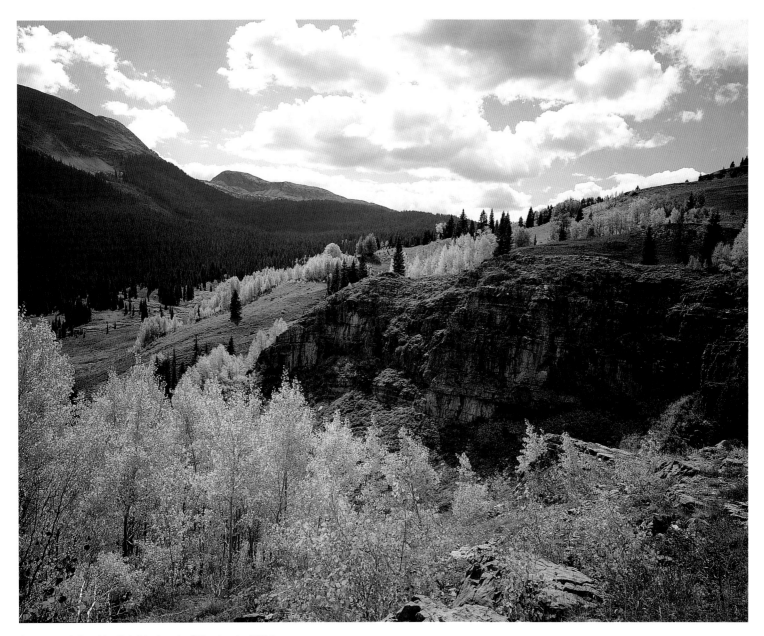

Aspens and Gamble Oak blanket the Weminuche Wilderness.

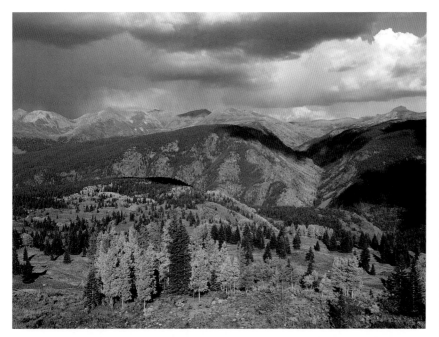

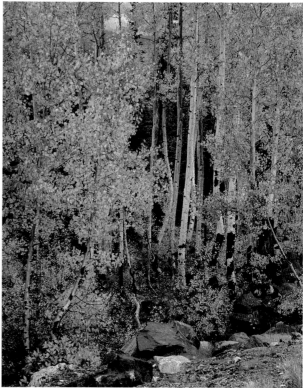

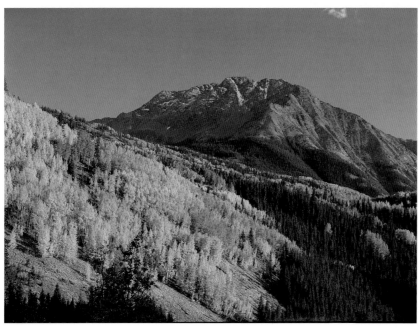

Durango's Fall colors attract viewers from across the country.

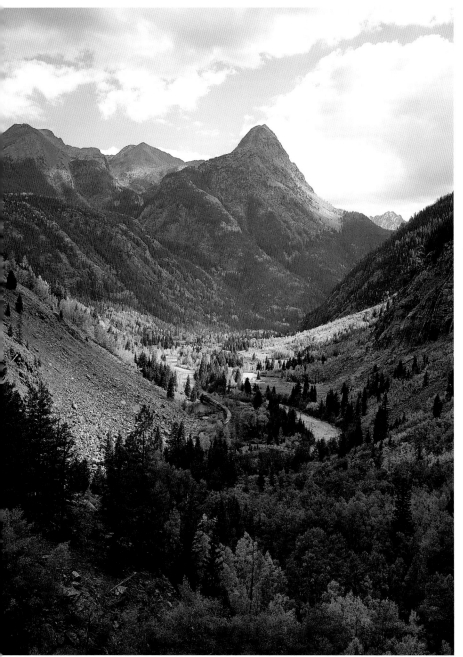

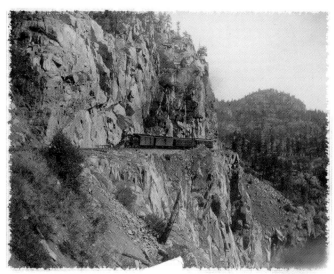

The Durango & Rio Grande train, Silverton Branch, rides the High Line just north of Rockwood siding, circa 1884. The D&RG completed construction of the railroad into Durango in August, 1881. To reach Silverton, they had to blast a ledge along the cliffs beyond Rockwood, above the Animas River. Surveyors and workers would rappel over the canyon walls to mark and then blast a shelf for the rails. In July 1882, the route to Silverton was complete.

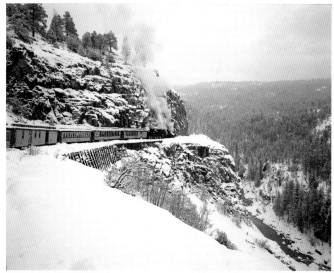

The High Line today.

The train passes through Elk Park in the Weminuche Wilderness, under Mt. Garfield. Designated a wilderness in 1975, the train is the only mechanized transportation permitted within the Weminuche's boundaries. Backpackers can take the train into the wilderness, camp overnight, and be picked up the next day.

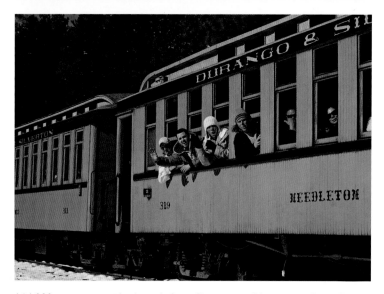

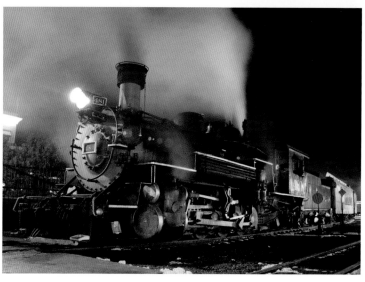

164,000 passengers ride the rails from Durango to Silverton or Cascade Canyon annually.

Locomotive 481 prepares for a night run during December's Polar Express. Based on the book and 2004 movie of the same name, children are encouraged to wear pajamas for the ride.

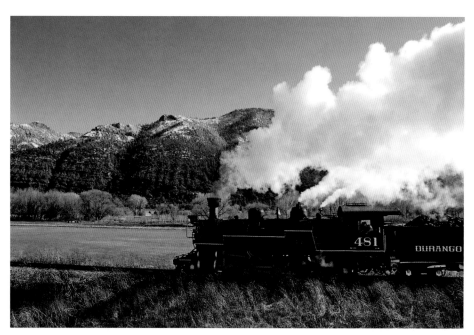

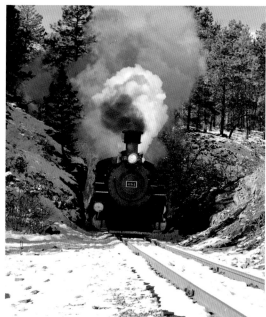

The train steams past Hermosa Cliffs, a distinct outcrop north of town. The red strata are sandstone from an ancient seabed, exposed when glaciers carved out the Animas Valley.

The rock cut just past Rockwood siding is seen in the movies *Around the World in 80 Days!* (for which a papier-maché bridge created a tunnel) and *Butch Cassidy and the Sundance Kid*.

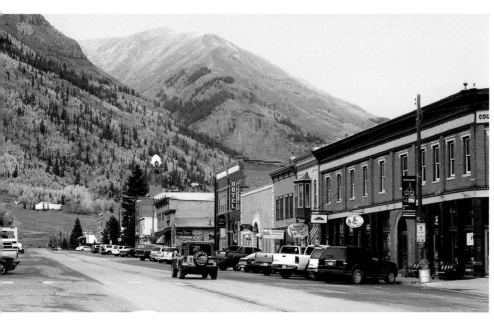

Greene Street, downtown Silverton. Located fifty miles north of Durango, Silverton is named for the metal that made the town a mining mecca. Laid out in 1874, despite protests by the Ute tribes on whose land the town and mines were located, Silverton had 2,000 people by 1883 with 400 buildings, including 29 saloons and a healthy red-light district, Blair Street. Fines levied against prostitutes and dance halls that were open on Sundays greatly contributed to the coffers of the growing town. In the 1990s, the last big mine closed, and today the year-round population is about 500 (www.silvertoncolorado.com).

Silverton has a small but vibrant commercial district along Greene Street, its main street. Though most of its seasonal economy is reliant upon tourists arriving on the train from May through October and those driving scenic U.S. 550, Silverton is gaining a national reputation for its small but extreme Silverton Mountain Ski Area, and more moderate Kendall Mountain Recreation Area (www.silvertonmountain.com).

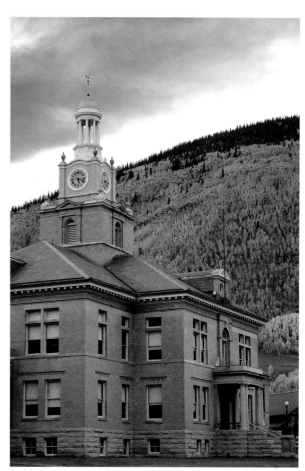

Silverton is the only town left in San Juan County. Its courthouse, still in use, was built in 1907. Its dome is gold leafed.

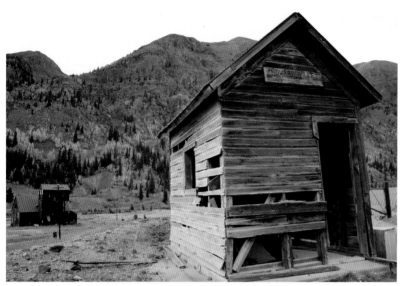

Ruins of Howardsville, just north of Silverton. Founded and named by George How-
ard, the little town was home and supply point to many prospectors by the mid-
1870s. Howard built his first log cabin there by offering prospectors arriving over
the Stony Pass Trail a swig of whiskey from a barrel he kept next to a pile of logs.
They could earn the whiskey if they would help lift the logs into place. Howards-
ville was originally the La Plata county seat, until it was moved to larger Silverton
in 1876, when the large La Plata County was broken up and San Juan County was
formed.

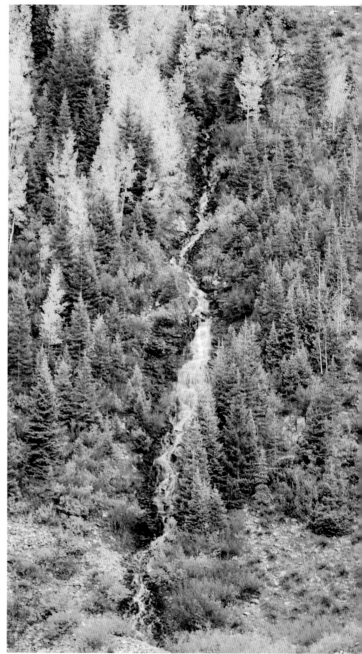

A waterfall cascades down one of Silverton's steep, mineral-
rich mountainsides. At its peak in 1890, the Silverton area
had more than 100 mines, but most quickly closed in 1893
after the repeal of the Sherman Purchase Act, which caused
silver prices to plummet. Today, you can tour the Mayflower
Gold Mill and the Old Hundred Gold Mine, where you travel
1,500 feet underground in mining cars. www.minetour.com.

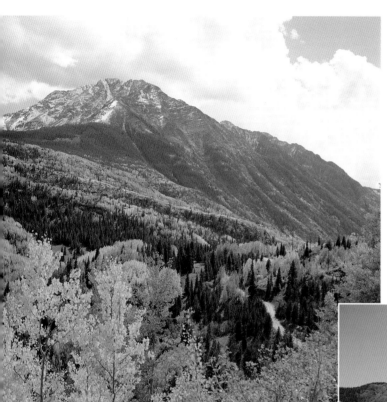

Fall color in the mountains above Silverton.

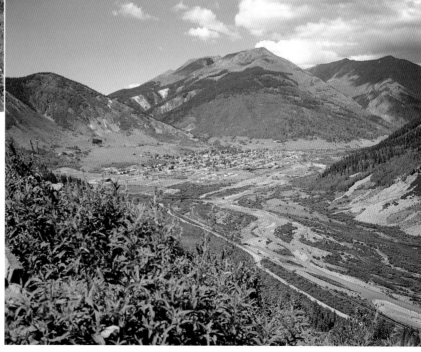

Silverton, as seen from the top of Molas Pass.

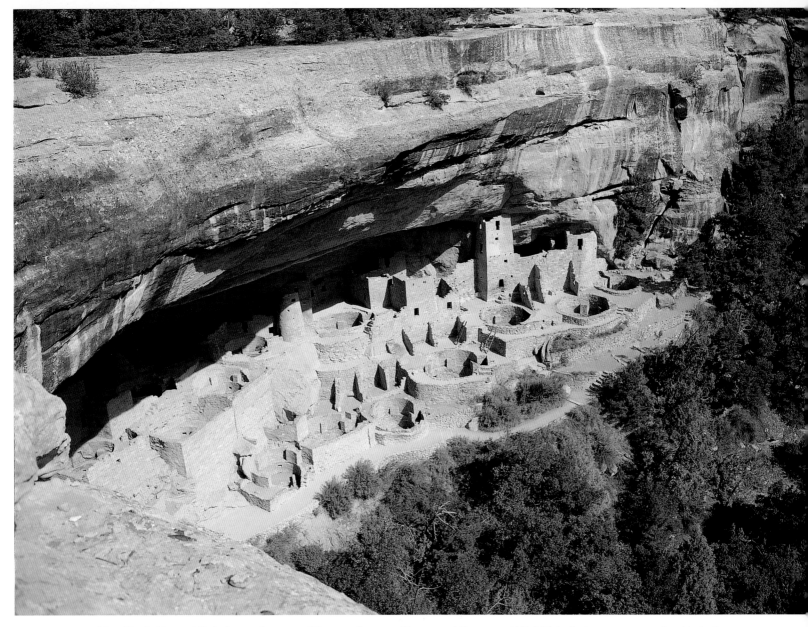

Mesa Verde National Park, forty miles west of Durango between Mancos and Cortez on U.S. 160, is the largest protected archeological site in the United States. Designated a National Park in 1906 by Theodore Roosevelt, it was named a World Heritage Site in 1978. More than 4,000 ancestral pueblo sites are protected here, spanning A.D. 600 to A.D. 1300. Cliff Palace, pictured here, was rediscovered in December of 1888 by ranchers Richard Wetherill and Charlie Mason as they searched for stray cattle (www.nps.gov/meve).

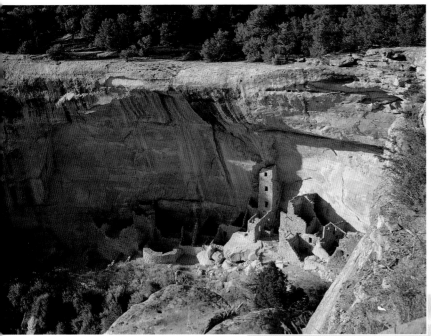

Square House Ruin is a four-story-tall tower, the remains of a larger, tiered structure built in the 13th century. It is the tallest ruin in Mesa Verde.

After 266-room Cliff Palace, Long House Ruin is the second largest ruin at Mesa Verde. It is believed that its open spaces were used for dances and ceremonies.

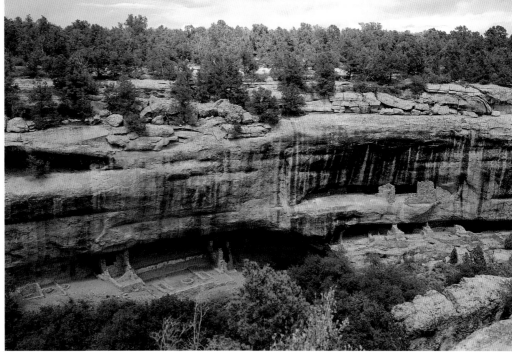

Chimney Rock Archaeological Area is located in the San Juan National Forest between Durango and Pagosa Springs. A contemporary of Mesa Verde, Chimney Rock is a Chaco Canyon outlier, meaning that it is associated with the ancestral pueblo "capital" at Chaco Canyon in New Mexico, some 100 miles southeast. The Chimney Rock is open for tours from May through September (www.chimneyrockco.org)

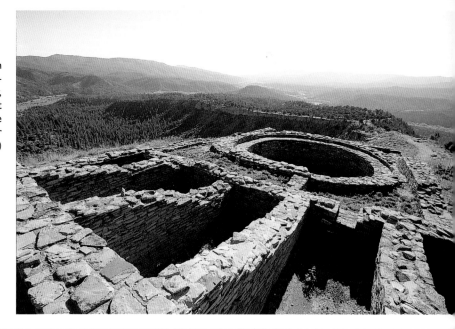

The rock formation that gave Chimney Rock its name. Many archaeologists believe these 1,000-foot-high formations were the reason this spot was chosen. From the ruins, at certain times of the year, the moon rises between the two spires, perhaps marking important agricultural or ceremonial times. Other ancestral pueblo sites, including many at Chaco Canyon, also are aligned to astronomical events, such as the summer solstice. The Puebloans were aware of astronomical movements and oriented their enormous structures along lines of equinoxes, solstices, and lunar events, which were used to indicate planting, harvesting, and ceremony times. By using a system of fires, the Puebloans could communicate very quickly over vast distances.

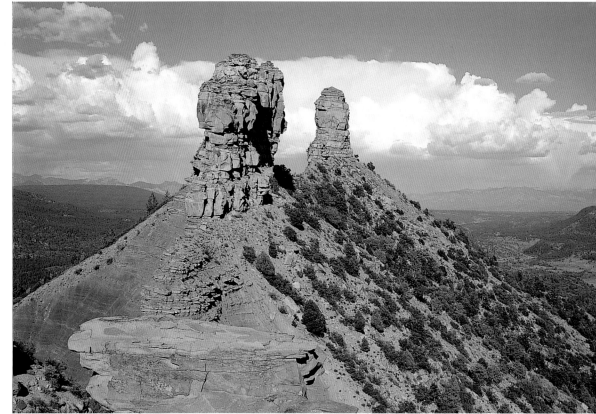

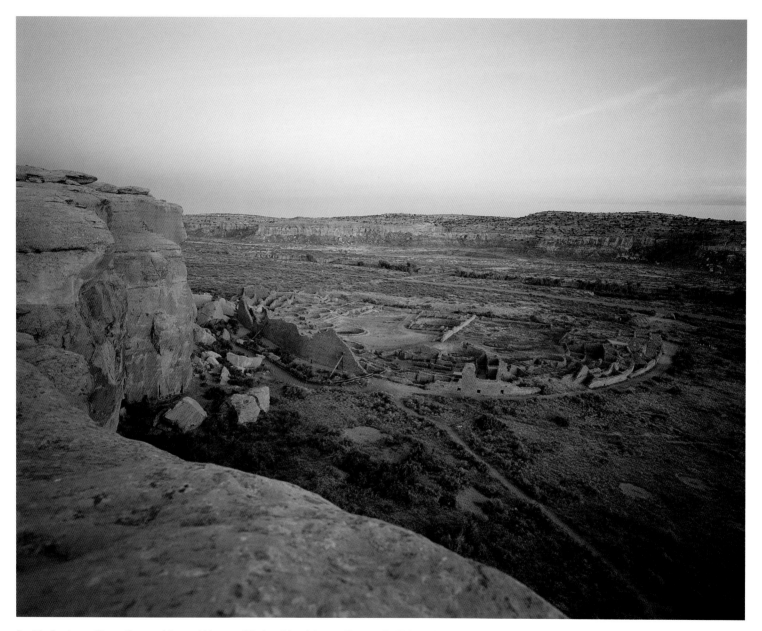

Pueblo Bonito at Chaco Canyon National Historical Park in New Mexico. From A.D. 850 to 1300, this area was the center of the vast Puebloan world. Though the Chacoans didn't have the wheel, perfectly straight roads radiated from Chaco Canyon to outlying communities hundreds of miles away, including Chimney Rock, east of Durango. Scientists believe that social strife brought on by an extended drought forced the Chacoans to abandon Chaco Canyon. They relocated to pueblos mostly along the Rio Grande River in New Mexico. The pueblos, as well as the lands of the Hopis in Arizona, are still there today. (www.nps.gov/chuc/).

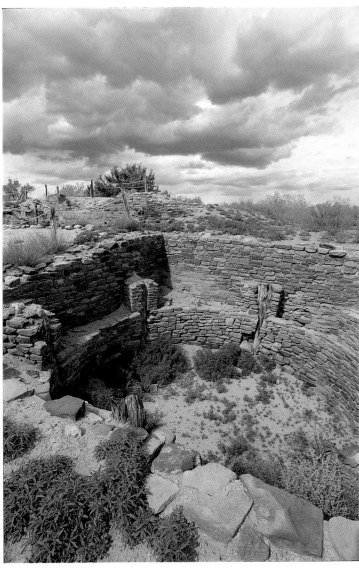

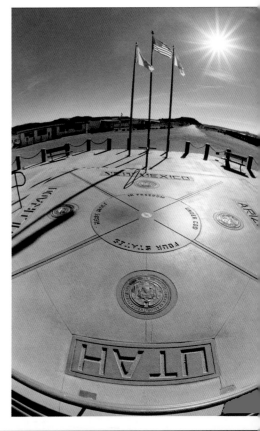

The Four Corners Monument, about eighty-four miles southwest of Durango on U.S. 160, marks the only place in the United State where four states meet (Colorado, Utah, Arizona, and New Mexico). The monument was established in 1912 and is administered by the Navajo Park and Recreation Department, six miles northeast of Arizona's Teec Nos Pos trading post.

Above & bottom right:
Salmon Ruins in Bloomfield, New Mexico, and Aztec Ruins National Monument in Aztec, New Mexico, both about 20 miles south of Durango, are also Chacoan outliers. Aztec Ruins has an impressive reconstructed great kiva, or underground ceremonial chamber, like those found at most ancestral pueblo sites (www.nps.gov/azru).

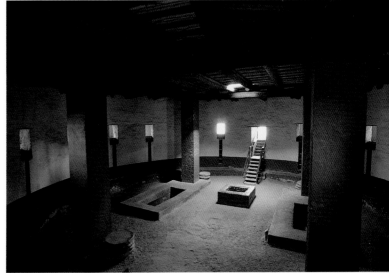

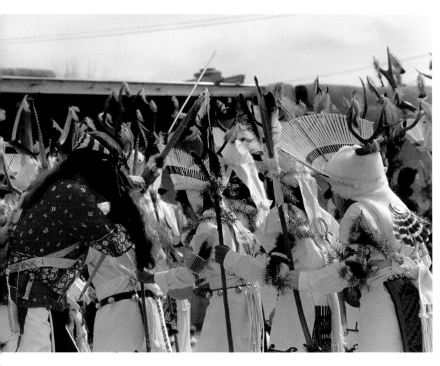

he descendants of the Puebloans who lived at Chaco Canyon, Mesa Verde, Chimney Rock, nd other ancient site are with us today, embracing the future while respecting their past, uch as at this Deer Dance at Ohkay Owingeh Pueblo, New Mexico.

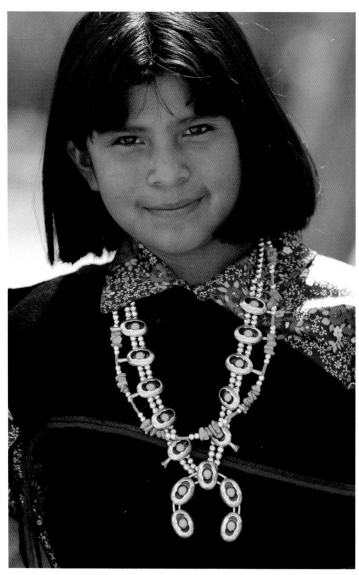

A young Santa Clara Pueblo dancer, from New Mexico, prepares for a social dance honoring her ancestors.

The lobby of the General Palmer Hotel, at 567 Main Street in Durango. Built in 1898, this Victorian hotel is named for William Jackson Palmer, who served as a Union general in the Civil War in which he earned the Medal of Honor. A civil engineer before and after the war, he studied railroads abroad in Britain. He brought back the concept of the narrow gauge railroad and founded the Denver & Rio Grande Western Railroad, 45 miles of which is the Durango and Silverton Narrow Gauge Railroad today. He went on to found Colorado Springs in 1871 and to financially support educational opportunities for former slaves. He died in 1909 at age 72.

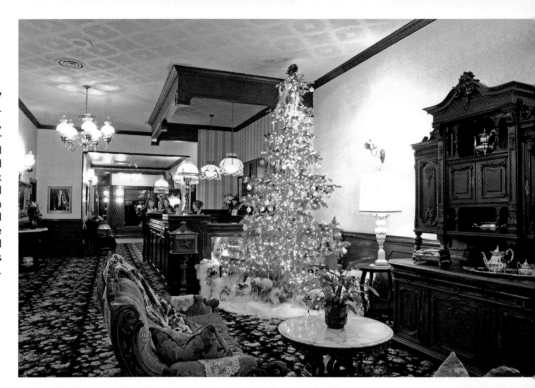

The D&SNG museum incorporates a wall and track from the original roundhouse and hundreds of items related to Durango's railroading history, including a RGS Locomotive 42 engine and a passenger car used in the film *Butch Cassidy and the Sundance Kid*. As seen in this photograph, the museum hosts the Festival of Trees, an annual holiday fund-raiser for local charities.

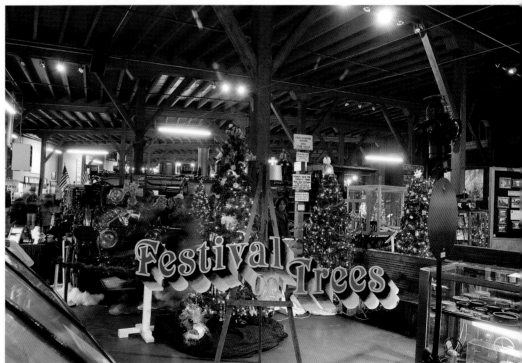

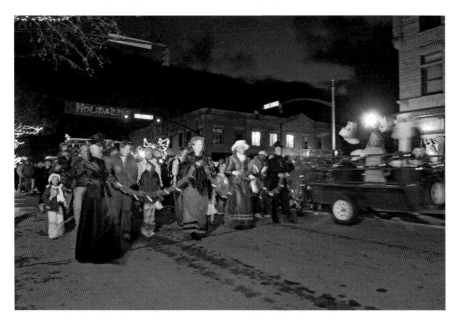

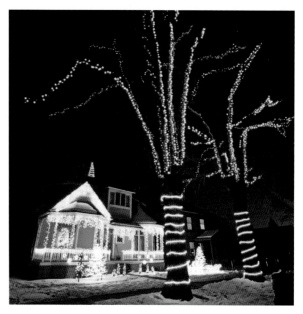

The Victorian Aid Society of Durango leads the annual Holidazzle parade down Main Street. The parade ends with the lighting of a Christmas tree at Buckley Park and visits with Santa Claus. Formed in 1997 by Carrie Foisel and Linda Evans, friends who share a passion for Durango's Victorian past, the Society now leads cemetery tours, living history performances, holiday events, and other activities to promote awareness of Durango's history (www.victorianaidsociety.org).

Christmas lights along Third Street. When William Jackson Palmer and William A. Bell designed Durango, they laid out a grid, with residential areas on high ground away from industrial areas. Home lots were 25 feet wide and 150 feet long, with prices beginning at $200. Third Street was originally designed to accommodate horse-drawn buggies and it had a tree-lined median, which is still there today. Many of Durango's first residents had come from the East and wanted to recreate a neighborhood similar to what they had left. Schools and churches soon followed. The street today is listed as a National Register Historic District and has excellent examples of home styles from the 1880s to the 1930s.

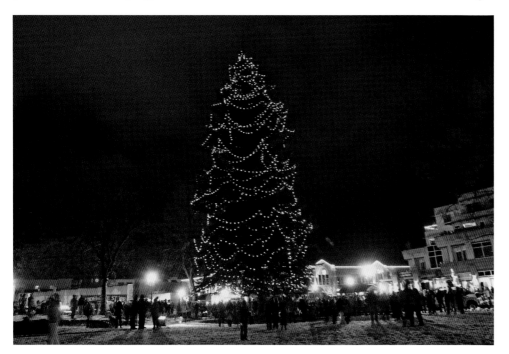

Revelers gather at Buckley Park to light the city's Christmas tree.

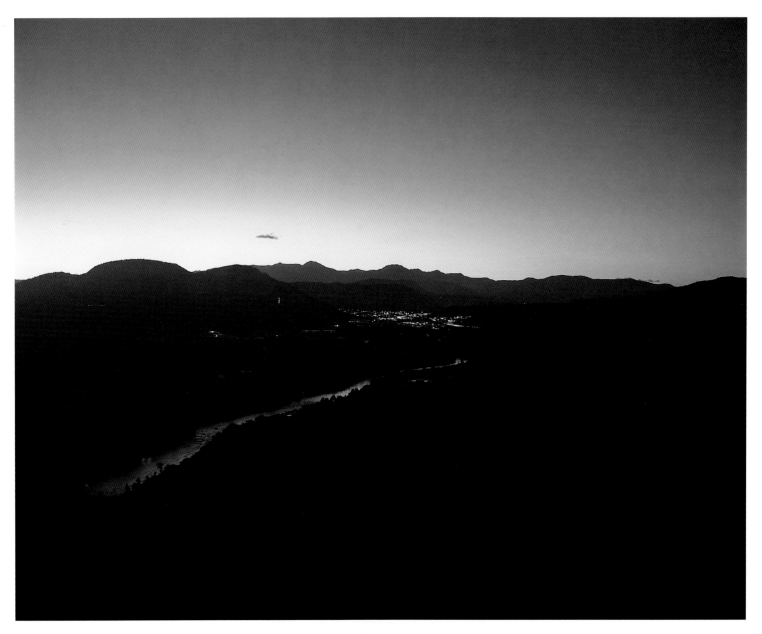

The lights of Durango begin to glow as the setting sun mirrors upon the Animas river.

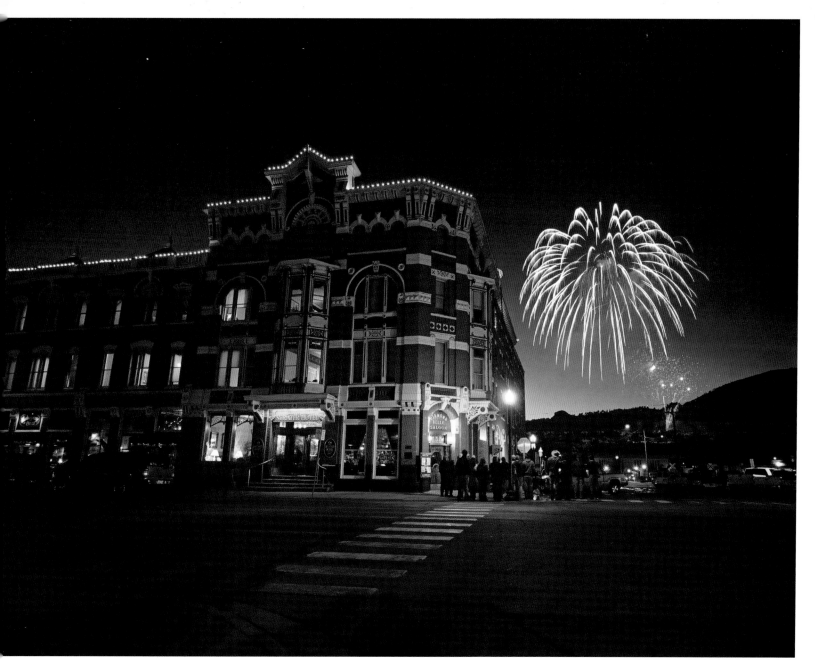

Fireworks light up the sky behind the Strater Hotel, celebrating the beginning of another year in Durango.

RESOURCES

Useful Web Sites

City of Durango Web site
www.durangogov.org

Durango Area Tourism Office
(800) 525-8855, www.durango.org

Durango Business Improvement District
www.downtowndurango.org

Durango Chamber of Commerce
www.durangobusiness.org

Durango Downtown
durangodowntown.com

Durango Herald newspaper
www.durangoherald.com

Durango Telegraph newspaper
www.durangotelegraph.com

Southern Ute Indian Tribe
www.southern-ute.nsn.us

Museums/Attractions

Animas Museum
3065 West 2nd. Ave.
Durango, CO 81302
(970) 259-2402
www.animasmuseum.org

Chimney Rock Archeological Area
Open May15-Sept. 30
3 miles South of Hwy 160 on Hwy 151
(970) 883-5359
www.chimneyrockco.org

Durango Discovery Kids
802 E. 2nd Ave.
Durango, CO 81301
(upstairs in the Durango Arts Center)
(970) 259-9234
www.childsmuseum.org

Durango Discovery Museum
1333 Camino del Rio
Durango, CO 81301
(970) 422-2034
www.durangodiscovery.org

Durango & Silverton Narrow Gauge
Railroad and Museum
479 Main Ave.
Durango, CO 81301
(970) 247-2733
www.durangotrain.com

Mesa Verde National Park
Mesa Verde, CO 81330
(970) 529-4465
www.nps.gov/meve

San Juan County Historical Society
1569 Greene St.
Silverton, CO 81433
(970) 387-5838

Major Annual Events

January-February
Snowdown
www.snowdown.org

February
Durango Chocolate Fantasia
(970) 259-1021

March
Durango Independent Film Festival
www.durangofilm.org

Hozhoni Days

Fort Lewis College
www.fortlewis.edu

May
Durango Farmers Market
Opens in May
www.durangofarmersmarket.org

Taste of Durango
www.tasteofdurango.com

Memorial Day weekend
Iron Horse Bicycle Classic
(970) 259-4621
www.ironhorsebicycleclassic.com

June
Animas River Days
www.animasriverkeeper.com

July
Durango Fiesta Days
www.durangofiestadays.com

July through August
Music in the Mountains
www.musicinthemountains.com

August
La Plata County Fair
www.co.lapalta.co.us

Rail Fest
www.durangotrain.com

September
Four Corners Bike Rally
www.fourcornersbikerally.com

Southern Ute Tribal Fair & Powwow
www.southern-ute.nsn.us

October
Durango Cowboy Poetry Gathering
www.durangocowboygathering.org

Durango Heritage Celebration
www.durangoheritagecelebration.org

November
Durango Mountain Resort
Opening Day, November
www.durangomountainresort.com

December
Holidazzle Parade & Tree Lighting
www.durango.org

AUTHOR

Steve Larese is a photographer, writer, and editor specializing in the cultures and history of the American Southwest. His award-winning travel writing and photography appear in magazines and books internationally. He may be reached at www.stevelarese.com.